BOEING

IN PHOTOGRAPHS A CENTURY OF FLIGHT

On 26 October 2001 the Department of Defense announced that the Lockheed Martin X-35 was the winner of the JSF competition, with the Boeing X-32 losing out against the Lockheed submission. The X-35 would be developed into the production F-35 Lightning II.

BOEING

IN PHOTOGRAPHS A CENTURY OF FLIGHT

MARTIN W. BOWMAN

The
History
Press

KLM 747-406(M) PH-BFH *City of Hong Kong* leaving Schiphol. This aircraft first flew on 30 March 1990. (Author)

YAL-1A 00-0001 of the 417th Flight Test Squadron. The YAL-1 Airborne Laser Testbed (formerly Airborne Laser) weapons system was a megawatt-class chemical oxygen iodine laser (COIL) mounted inside a modified 747-400F. It was designed primarily as a missile defence system to destroy tactical ballistic missiles (TBMs) while in boost phase. The aircraft was designated YAL-1A in 2004 by the Department of Defense. A low-powered laser was test-fired in flight at an airborne target in 2007. A high-energy laser was used to intercept a test target in January 2010 and the following month, successfully destroyed two test missiles.

After the war, Boeing capitalised on its wartime production successes by producing many notable civil and military designs, such as the C-135 series, which was also the progenitor of the Model 707 transports, and the B-52 Stratofortress nuclear bomber, which was the backbone of Strategic Air Command from June 1965 until the early 1990s.

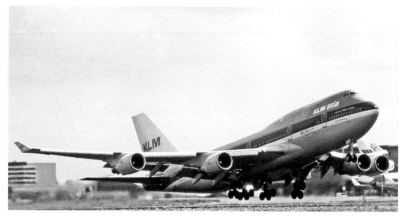

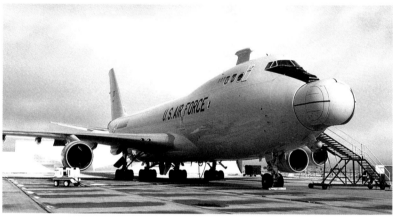

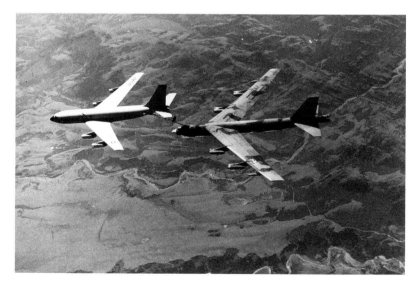

First published 2016
This paperback edition published 2023

The History Press
97 St George's Place
Cheltenham GL50 3QB
www.thehistorypress.co.uk

British Library Cataloguing in Publication Data.
A catalogue record for this book is available from the British Library.

ISBN 978 1 80399 117 7

Typesetting and origination by The History Press
Printed in Turkey by Imak

Trees for Life

CONTENTS

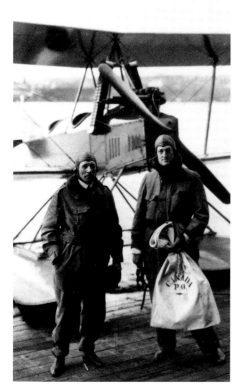

W.E. Boeing (right) and Eddie Hubbard in March 1919 in front of the C-700 seaplane at Vancouver, Canada. The C-700 was used by William Boeing to carry the first US international contract airmail from Seattle to British Columbia.

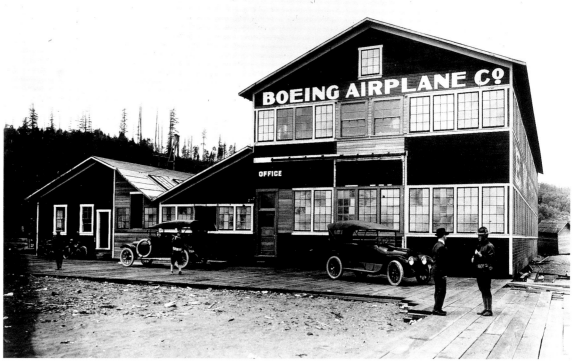

The main building (known as the 'Red Barn') at the former Heath Shipyard, a small yacht-building firm on the Duwamish River, which Boeing used from 1917. It is seen here on 8 June 1917 when it was under guard. The Red Barn was restored in the 1970s and relocated to Boeing Field as part of the Museum of Flight complex.

ACKNOWLEDGEMENTS

The author would like to thank: Mike Bailey; Kenneth Fields; Wallace Fields; Tom Fitton; Brian Foskett; Lt-Col. Harry D. Gobrecht; Terry Holloway; Tom Lubbesmeyer of the Boeing Co.; Gerry Manning; Marshall Aerospace; Brian McGuire; Jerry C. Scutts; Graham M. Simons; Hans Heri Stapfer; the dedicated staff of the US 2nd Air Division Memorial Library in Norwich, including Derek S. Hills, Trust Librarian; Linda J. Berube, American Fulbright Librarian; Lesley Fleetwood; and Christine Snowden – all of whom were most helpful and who provided much willing assistance with research.

INTRODUCTION

The Boeing Company was founded by William E. Boeing, the son of a wealthy timberman. At the age of thirty-four, Boeing took up flying for his own amusement. After a couple of rides, he became convinced that he could build a better aeroplane. He and Commander G. Conrad Westervelt, a navy officer assigned to engineering work at a shipyard in Seattle, Washington, decided to build a pair of seaplanes. By December 1915, an aeroplane called the B & W Seaplane was under construction in a hangar on the east shore of Lake Union. *Bluebird*, the first B & W, was completed in early 1916, marking the modest beginning of aircraft production at the Boeing Company. It flew for the first time on 29 June 1916.

Although aircraft work had been in progress since 1915, corporate identity was not achieved until the Pacific Aero Products Company was incorporated on 15 July 1916. On 26 April 1917 the name was changed to The Boeing Airplane Company, without change of corporate structure or management. The small speciality shop, with a twenty-one-man workforce, became a major aircraft manufacturer during the First World War. The Model C followed the B & W and was the first all-Boeing design. The US Navy ordered two Model Cs for testing. US entry into the First World War created a sudden demand for primary training planes. As a result, fifty additional Model Cs were ordered. Later, one additional Model C was built for William E. Boeing. This was logically called the C-700 because the previous airframe had been known in the shops by its US Navy serial number, 699. The C-700 was used by William Boeing and Eddie

Hubbard to carry the first US international contract airmail from Seattle to British Columbia (see p. 6). In 1918 Boeing was asked to build fifty Curtiss HS-2L flying boats for the US Navy.

The Boeing Company, which had moved its manufacturing facilities to the Heath Shipyard on the Duwamish River, south of Seattle, struggled through the first disastrous post-war years by accepting military orders for the manufacture of

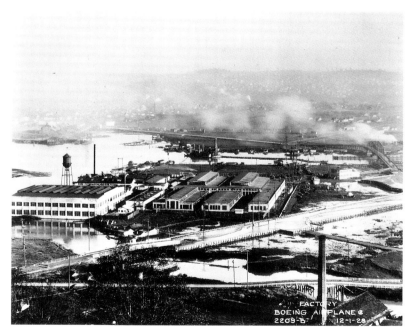

The Boeing aeroplane factory, 1 December 1928. A few of the original Heath Shipyard buildings can be seen behind the large assembly plant at the water's edge.

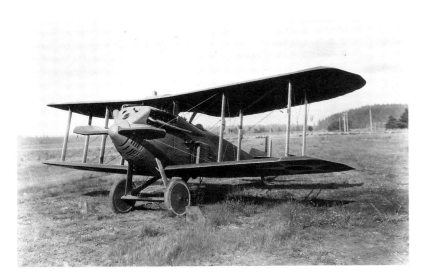

In 1921, Boeing won a contract to build 200 Thomas-Morse MB-3A pursuit planes for the AAC. It provided the company with valuable design experience that enabled Boeing to build a successful series of pursuit aircraft between 1924 and 1936.

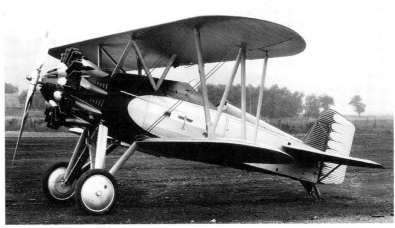

In the summer of 1928, the Model 83 (XF4B-1 No. 1) and the Model 89 (XF4B-1 No. 2, pictured here on 25 July 1928) flew for the first time. They led to very large P-12/F-4B production runs for the army and the navy respectively, which by February 1933 totalled 586 aircraft.

Sea Sled boats, canoes, and bedroom furniture. Not until 1920 did prospects look better, when the production of 200 Thomas Morse MB-3A single-seat fighters and the rebuilding of 354 Liberty-engined de Havilland DH.4s was undertaken from 1920 to 1925. The early fame of Boeing was earned by its position as the leading supplier of single-seat fighting planes between 1924 and 1936. Work on the Boeing Model 15 biplane fighter began in 1922 and the XPW-9 flew for the first time on 2 June 1923. Forty-nine PW-9 production models for the army followed. Ten FB-1 models were ordered by the navy. Further improvements kept the Model 15 in production until 1928, and improved versions and new models continued into the late 1930s.

In 1929, ninety examples of the Boeing P-12B were ordered, the largest single army order for fighters since 1921. Altogether, 586 aircraft in the P-12/F-4B series were delivered to the army and the navy (and a few overseas); the last was on 28 February 1933. Boeing's Model 248, which appeared in March 1932, was the first all-metal monoplane fighter and three prototypes were built at its own expense. After testing as the XP-936, the army purchased these and went on to order 136 P-26 production examples.

Before the fighter business tapered off, Boeing switched production to the potentially more lucrative transport business. When transcontinental airmail routes operated by the Post Office Department were handed over to private operators in 1927, Boeing's low bid for the key leg from San Francisco to Chicago was

accepted and a new airline subsidiary, Boeing Air Transport, was formed. The Seattle factory redesigned the 1925 Model 40 to take the new air-cooled Wasp engine and built twenty-four Model 40As in just six months, ready for service with the new airline. Its competitors, meanwhile, continued to use the heavier, water-cooled, Liberty-engined aircraft for mail service. In addition to having space for 1,200lb of air mail, the Model 40A had room for two passengers in a small cabin ahead of the pilot's open cockpit. Later models carried four passengers. A total of eighty-two Model 40s were built. Their introduction signalled the beginning of regular commercial passenger services over long distances and served as the vehicle for the first regular passenger and night mail flights.

The success of the passenger operations with Model 40s on the San Francisco-Chicago route encouraged expansion of the business through the addition of larger aircraft designed specifically for passenger convenience and comfort. In 1928 Pacific Air Transport (PAT), a San Francisco to Seattle airline, was purchased. The two airlines were merged to become The Boeing System. The first of four Model 80 trimotor biplanes, the last word in air transportation, was delivered to Boeing Air Transport in August 1928, only two weeks after its first flight. Twelve passengers and later eighteen passengers were carried in a large cabin provided with hot and cold running water, a toilet, forced air ventilation, leather upholstered seats and individual reading lamps. The

needs of a dozen or more passengers during long flights soon indicated the desirability of a cabin attendant who could devote full attention to their comfort. While some European airlines used male stewards, Boeing Air Transport hired female registered nurses who became the first of the now-universal stewardesses. The pilot and co-pilot were enclosed in a roomy cabin ahead of and separate from the passenger cabin.

Boeing, meanwhile, expanded rapidly. In February 1929 it acquired the Hamilton Metalplane Co. of Milwaukee, Wisconsin, and that summer established a Canadian subsidiary (Boeing Aircraft of Canada) in Vancouver, Canada, where it began building C-204 flying boats. A powerful holding company was formed with the merger of the Boeing aeroplane and airline operations and Pratt & Whitney, a leading aeroplane engine manufacturer, Hamilton Aero Manufacturing Co., and another aeroplane manufacturer, Chance Vought Corporation, to form the United Aircraft and Transport Corporation. Each company continued to produce its own specialised product under its own name while the airlines operated under their own names within a holding company known as United Air Lines. Three airlines were acquired and added to the existing operation, while the manufacturing

companies Sikorsky Aviation and Standard Steel Propeller Co. were bought up.

With one eye on the military trainer market, on 1 April 1938 the Boeing Aircraft Company bought the Stearman Aircraft Co., based in Wichita, Kansas, to create the Stearman Aircraft Division (renamed the Wichita Division in 1941). Beginning in 1939, the Wichita plant began turning out Stearman primary biplane trainers by the hundred for the US Navy and US Army Air Corps. Stearmans were destined to be built in greater numbers than any other biplane in American history.

When markets for new aeroplane designs developed, Boeing was ready with new models and processes. It was the first American manufacturer to use welded steel tubing for fuselage structure, a feature that soon became standard throughout the industry until generally replaced by monocoque sheet metal structures in the mid-1930s. Boeing again demonstrated its technological leadership by introducing this new construction, matched to aerodynamically advanced aeroplanes, in both commercial and military production with the Monomail, B-9 and 247 models of 1930–33.

The all-metal Model 200 Monomail mail and cargo carrier, which first flew on 6 May 1930, was one of the most revolutionary aeroplanes in commercial aviation history. Designed initially as a combination mail and passenger aeroplane, its increased performance resulted from structural and aerodynamic refinements, not the addition of brute horsepower. The traditional biplane design with drag-producing struts and wires was replaced by a single, smooth, all-metal low wing of clean cantilever construction. The wheels were retracted into the wing during flight, and the drag of the air-cooled Hornet engine was greatly reduced by enclosing it in a newly developed anti-drag cowling. However, the Monomail's sleek aerodynamic design was too advanced for the power plants of the day. Efficient use of its full performance range required a variable-pitch propeller. When one was eventually installed, the aircraft was already on the verge of being replaced by the newer multi-engine designs it had inspired.

Boeing Models 214 and 215, which became the US Army Y1B-9 and YB-9, were logical military developments of the Monomail. Boeing embarked on the two B-9 projects as a private venture in anticipation that they would produce the same performance advance in the area of heavy bombers as the Monomail had done in the commercial sector, but the type was not ordered in quantity. The B-9 did, however, prove a major advance in bomber design and it greatly influenced the Model 247, the first airliner produced in quantity by Boeing.

An unprecedented decision was made to re-equip completely the Boeing Air Transport System with the innovative new twelve-seater transport and an order for sixty Model 247s was placed while the design was still in the mock-up stage. The Model 247 was the first all-metal streamlined monoplane

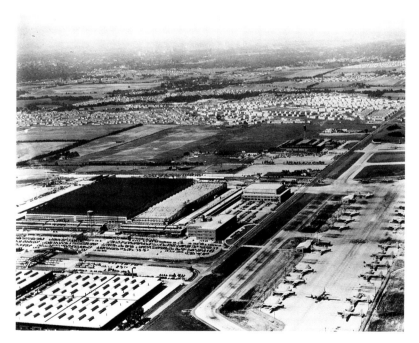

Boeing Wichita, Kansas, built and owned by the US government for B-29 production, turned out 1,644 Superfortresses. The original Stearman Aircraft Co. buildings (Plant 1) can be seen in the background.

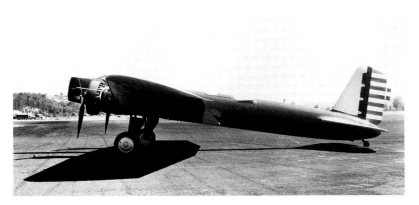

During the 1930s Boeing also produced some exciting transport and bomber aircraft. The Model 214 (Y1B-9) of 1931 was a military development of the Monomail mail and cargo carrying plane.

The P-26A (Model 248) was the first all-metal monoplane in US Air Corps pursuit squadron service and 136 'Peashooters' were delivered between 1933 and 1936.

Ever innovative, Boeing cleaned up the P-36 design to produce, in 1934, the XP-940 pursuit monoplane, but the gross weight restricted manoeuvrability and service ceiling and P-29A production orders never materialised. Boeing dropped out of the fighter business and concentrated instead on bombers.

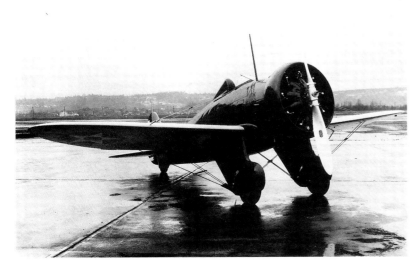

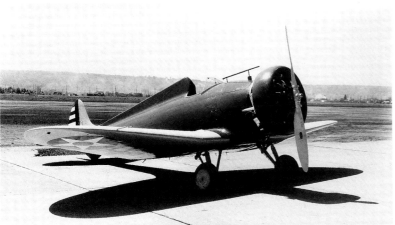

transport. It was powered by two supercharged Pratt and Whitney 550hp S1D1 Wasps (the first time superchargers had been used on a transport type) and featured retractable landing gear, an enclosed cabin, auto pilot, trim tabs, and de-icing equipment.

In 1934 Congress passed legislation that forced aircraft and engine manufacturers to end all their links with airline operations. On 26 September, a government trust-busting suit had separated United Aircraft's airline and manufacturing activities and the Boeing Aircraft Company, renamed from the Boeing Airplane Company and a separate entity from Boeing Air Transport, had pulled out of United. The Boeing Aircraft Company resumed independent operation and moved into the bomber business.

In the 1930s it was accepted that a formation of unescorted bombers could get through to their target if they were properly arranged and adequately armed. During air manoeuvres in 1933 pursuits (fighters) repeatedly failed to intercept the bombers and there was even talk of eliminating pursuits altogether. Funds for new aircraft were very limited and it was mostly manufacturers who funded new developments which in turn might attract orders from the military. (By 1934, Model 247 production was winding down and the only business Boeing had was unfinished contracts for P-26A and C fighters. In August, 1,100 of its 1,700 workforce were laid off. Cash in hand was barely $500,000.)

Boeing's first bomber development, in 1934, was the massive Model 294, or the XBLR-1 (experimental bomber, long range), which became the XB-15. That same year the air corps issued a specification for a 'multi-engined' bomber, but manufacturers would have to build prototypes at their own expense. Although the term 'multi-engined' generally meant two engines, the four-engined Model 299 was already in the design stage and so, on 16 September 1934, Boeing boldly decided to invest $275,000 in the Model 299. (Ultimately, it would cost more than $432,000 to build a prototype.) The new design, which was to

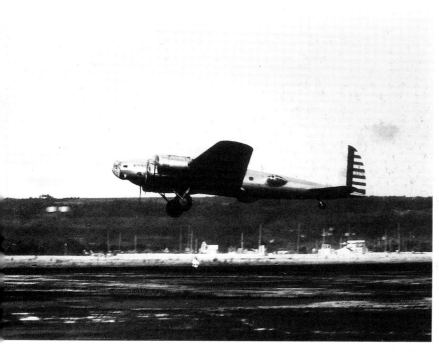

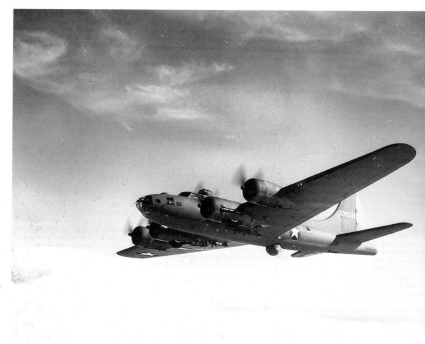

Flown for the first time on 28 July 1935 by the company test pilot Leslie Tower, the Model 299 signalled the beginning of the long line of famous Flying Fortress models for the United States Army Air Force (USAAF) in the Second World War.

In the Second World War Boeing turned out 2,300 B-17Fs (42-30243 from Block B-17F-95-BO is pictured). The F was followed by 4,035 Boeing-built 'G' models for the war effort.

become famous as the B-17, incorporated many lessons learned with the X-15, B-9 and Model 247. Powered by four 750hp Pratt and Whitney Hornet radials, it would carry all bombs internally and accommodate a crew of eight.

Completed in only a year, the Model 299 was rolled out at Boeing Field on 17 July 1935. A *Seattle Times* reporter dubbed the 15-ton machine – to be used in a defensive role to protect the American coastline from enemy surface fleets – a 'flying fortress'. At first, testing went very well indeed, but on 30 October 1935 the Model 299 crashed and burst into flames, killing Leslie Tower, the test pilot, and Major 'Pete' Hill, AAC. An investigation concluded that the crash was a result of the mechanical ground locks not having been unlocked prior to take-off. This prevented movement of the main control surfaces. This setback cost Boeing dearly. On 17 January 1936, Douglas received an order for 133 B-18s, while Boeing received only a service test order for thirteen improved B-299Bs and a static test model.

The first Y1B-17 also crashed, on 7 December 1936, but pilot error was to blame. The thirteen service test Y1B-17s went into service with the AAC and established many long-distance records, earning a well deserved reputation

for rugged construction and reliable operation. Further production orders were slow – a requirement for just ten B-17Bs was received in August 1937, and only twenty-nine more by June 1938. The government strained relations further by haggling over the cost of each bomber. Boeing was a small, independent company, with barely 600 employees, and tooling up in anticipation of large production orders had left it with no cash reserves. Eventually, the army agreed to pay $202,500 per B-17 – little consolation given the myriad problems that arose frequently with armament, navigational and bombing apparatus and engines, especially superchargers, which were a radical innovation at this time.

B-17B models were delivered to the AAC in 1939–40. Fitted with the Norden bomb sight for precision bombing, they soon gained a reputation for accuracy: it was said that a B-17 was able, in daylight, to drop a bomb in a 'pickle barrel' from 20,000ft! Pioneering operations in Europe by the RAF, which purchased twenty Fortress Is, soon exploded this myth. Combat experience was to reveal other deficiencies, notably armament, which were only alleviated by installing power-operated gun turrets. Bombing results were little better from 1942

Right: A new government-owned plant at Renton built 1,122 B-29A-BN Superfortresses by May 1946. At the end of the war the Renton and Wichita plants closed. Increased demand for military transports, however, led to the reopening of the Renton plant for the manufacture of C-97s in 1949, while Wichita reopened for the conversion of B-29 tankers. Renton then took over this contract when Wichita was used to build B-47s and it subsequently went on to produce Boeing C-135s and a succession of commercial jet transports.

onwards when the B-17 largely equipped the US 8th Air Force in East Anglia. As enemy defences improved, more and more guns were added, and the 'Fort' got heavier and heavier. Losses on occasion were critical yet, largely due to the introduction of long-range escort fighters, the Fortress remained in production throughout the Second World War, serving in every theatre. When production finished, a staggering 12,731 B-17s had been built by Boeing, Douglas and Lockheed. Of these, Boeing produced 6,981.

Another war-winning bomber to emerge from the Second World War was Boeing's even bigger B-29 Superfortress, which had been conceived as far back as 1938. Its fuselage was divided into three pressurised compartments, two of which were connected by a tunnel over the tandem bomb bays. It was far ahead of its contemporaries with ten-gun defensive armament in four remotely controlled power turrets and a single directly controlled tail turret. The first YB-29s were delivered to the 58th Very Heavy Bombardment Wing in July 1943. By the end of the year it was decided that the B-29 would equip the newly formed 20th Bomber Command in India and China for raids on Japanese targets. The first B-29 mission occurred on 5 June 1944. Throughout late 1944 and early 1945 the B-29s carried out high level daylight raids on Japanese targets, until in March 1945 Major General Curtis E. LeMay decided that as the B-29s could not hit their targets accurately, they must area bomb using incendiaries to burn up large areas of Japanese towns and cities in an attempt to wreck the country's war effort. All Japan came to fear the dreaded 'Bni-Ju'. In August 1945 two B-29s effectively brought the Pacific war to a dramatic and welcome end when atomic devices were dropped on Hiroshima and Nagasaki.

Altogether, 3,970 B-29s had been built when production ceased in 1946, including 2,766 by Boeing. In 1947 the improved B-50 Superfortress appeared, and that same year, on 17 December, the B-47 Stratojet pure jet bomber flew for the first time. In appearance, Boeing's final foray into the super-bomber business, the B-52 Stratofortress, was a direct development of the B-47. Designed as a nuclear bomber for service with SAC, the B-52 first flew on 15 April 1952, and altogether 744 B-52s were built, including 467 at Wichita.

Boeing meanwhile had also re-entered the commercial airliner market, starting in 1947 with the Model 377 Stratocruiser, which was produced side-by-side

with B-50s on the Seattle production lines until 1949. Three years later, in August 1952, Boeing announced that it was investing $16 million of its own money to build the prototype of an entirely new jet-powered transport, the 367-80, or 707 prototype. The American jet transport era began when the 367-80 first flew on 15 July 1954. From then on Boeing made the long haul and short-to-medium-range markets its own, with a succession of hugely successful air transports, from the 707-120, -320, and -420 intercontinental airliners, through to the 727-100 and -200 series, and, in 1967, the 737.

If the introduction of the 707 had been innovative, the appearance of the gigantic 747 in February 1969 was revolutionary. Three years earlier, Pan Am had placed an order for twenty-five 747-100s, or 'jumbo jets' as the press quickly dubbed these behemoths that carried 500 passengers. A new 780-acre site had to be built before production could begin in early 1967. This included the world's largest building, the 200 million-cubic feet Everett plant, at Paine Field, 30 miles north of Seattle. On 30 September 1968, the first 747 was rolled out. By 1975, the 747 was being produced in seven different models. The 747-200 series was followed in the summer of 1980 by the 747-300 programme when

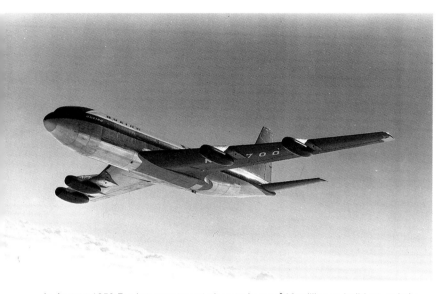

In August 1952 Boeing announced plans to invest $16 million to build an entirely new jet-powered transport, the Model 707. The prototype was followed, from 12 January 1958 onwards, by 725 commercial examples.

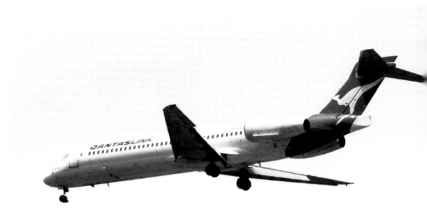

Qantas boeing 717-200 VH-NXD on approach to Perth on 5 January 2012.

Swiss Air ordered five aircraft. On 22 October 1985, Northwest Airlines was the first to order the even bigger 747-400 series.

Boeing's dominance in the commercial aircraft sector was further enhanced with the introduction of the 757 twinjet, which first flew in February 1982, and the 767 wide body twinjet, which entered commercial service on 8 September 1982. It was only in the 1990s that this dominance was seriously challenged by other manufacturers, such as Airbus. The 777, the newest member of the Boeing family, fits the same category as the McDonnell Douglas MD-11 and the Airbus A330/A340. On 29 October 1990, United Airlines placed a firm order for thirty-four 777 aircraft, plus an option for a further thirty-four. The 777 has effectively filled the capacity gap in that it can carry 375 to 400 passengers in two classes (the 767 carries between 290 and 325 passengers, while the newest 747 carries up to 566). With so many models to chose from it is not surprising therefore that the PR phrase 'If it's not Boeing, we're not going' was coined!

In the late 1980s Boeing established an Advanced Products Group to oversee the company's more futuristic aircraft and keep it at the forefront of technological development. The wide-body 777, originally scheduled to be introduced with the 757 and 767, attracted little interest and was temporarily shelved. The development of the fuel-efficient 777 was also delayed when declining fuel costs and rising research and development expenses reduced demand. By 1990 an initial order was received for thirty-four 777s, and with thirty-four options placed by United Airlines the new jet was put into official production.

The first 777-200 was delivered to United in 1995. Total sales of $16.3 billion were recorded in 1986, although Boeing's earnings declined steadily in the mid-1980s and the company missed its first delivery deadline in two decades when the 747-400 experienced production delays. These internal problems were exacerbated by increased competition from Airbus and a downturn in the commercial airline industry in 1990 but that same year Boeing posted record sales and net profits. Boeing experienced three years of rising sales and earnings from 1989 to 1992 but worldwide orders of all aircraft declined from 1,662 in 1989 to 439 in 1991 and cancellations further reduced expected delivery figures. At around the same time, the US Department of Defense spending was severely reduced as a result of the thaw in the Cold War. By late 1992 Boeing's stock was selling for about $35 per share, down from a high of nearly $62 in 1990. The workforce declined each year from 1989 to 1995, sales for 1993 dropped to $25.44 billion from $30.18 billion in 1992 and net earnings declined from $1.55 billion to $1.24 billion. By 1995 revenue and earnings had dropped to $19.52 billion and $393 million, respectively.

In 1993 NASA selected Boeing as the prime contractor for the International Space Station, which was called the largest international science and technology endeavour ever undertaken and was scheduled for completion in the early twenty-first century, before delays caused by economic turmoil in the Soviet Union. Boeing was also becoming increasingly involved in commercial space projects, most notably Sea Launch, a consortium 40 per cent owned by Boeing with partners from Russia, Ukraine and Norway. In December 1995 this venture received its first order: ten commercial space satellite launches from Hughes Space and Communication Co. In October 1999 Sea Launch made the first successful launch of a commercial satellite from a floating platform at sea. In October 1998 the US Air Force awarded Boeing a $1.38 billion contract to launch a new generation of rockets. In 1999 Boeing won a $4.5 billion contract to develop spy satellites for the CIA and others. Only in the commercial aircraft sector, where Airbus was becoming a formidable competitor, did Boeing lag behind.

The industry-wide difficulties in the aerospace and defence fields in the first half of the 1990s led to a wave of consolidation through mergers and acquisitions. Boeing completed two major acquisitions within an eight-month period. In December 1996 Boeing paid $3.2 billion for the aerospace and defence holdings of Rockwell International, which had existing contracts for the Space Shuttle and the International Space Station, as well as activities in launch systems, rocket engines, missiles, satellites, military aircraft and guidance and navigation systems. On 25 October McDonnell Douglas, the world's number three commercial aircraft manufacturer, had announced it would not pursue development of the MD-XX superjumbo programme. The announcement signalled the end of the company's position as a major commercial aircraft producer.

The most serious setback for the company occurred on 16 November when Boeing and Lockheed Martin received US defence contracts worth potentially $160 billion to build and test two competitive technology demonstrators for the Joint Strike Fighter, intended as an affordable, next-generation, multirole fighter for the US Air Force, Marine Corps and Navy and the Royal Navy. On 15 December Boeing and McDonnell Douglas announced that the two aerospace giants would merge in a $13.3 billion stock-for-stock transaction. It was the largest merger ever in the aviation industry and it catapulted Boeing into the number one position worldwide in the aerospace industry and increased its share of the world market for large commercial jetliners to more than 60 per cent. Boeing's only major competitor now was the European Airbus consortium, which held about one-third of the world market. The merger enabled Boeing to enlarge its defence and space operations as McDonnell Douglas was number two among US defence contractors and the number one producer of military aircraft worldwide with F/A-18 Hornets for the US Navy and the F-15 Eagle for the US Air Force.

Production doubled over an eighteen-month period, 1996–97, but Boeing faced a shortage of staff and a shortage of parts and the resulting delays compelled the company to halt the assembly lines of the 737 and 747 for one month. Furthermore, the production of the MD-80 and MD-90 passenger aircraft was on the decline, causing a net loss of $178 million on revenues of $45.8 billion and the first annual loss since 1947. After McDonnell Douglas merged with Boeing in 1997 the new company decided that MD-11 production would continue, though only for the freighter variant. However, in 1998 Boeing announced that after fulfilling current orders the production of the MD-11 would end, whereby the 717 (formerly the MD-95) became the only remaining model of McDonnell Douglas. Boeing also decided to phase out production of the MD-80 and MD-90 jets by early 2000. The last passenger MD-11 built was delivered to Sabena in April 1998. Assembly of the last two MD-11s was completed in August and October 2000; they were delivered to Lufthansa Cargo on 22 February and 25 January 2001 respectively.

In 1998 the defence and space operations performed well. Overall, Boeing increased the number of aircraft it produced from the 374 of 1997 to more than 550 in 1998. The workforce was expected to be reduced from its peak of 238,000 at year-end 1997 to between 185,000 and 195,000 by the end of 2000.

In 2000 Boeing acquired the space and communications division of Hughes Electronics Corporation, the world's largest satellite manufacturer. A year later Boeing's headquarters were moved from Seattle to Chicago. On 26 October 2001 the Department of Defense announced that the Lockheed Martin X-35 was the winner of the JSF competition with the Boeing X-32. The X-35 would be developed into the production F-35 Lightning II. The loss of the JSF contract was a major blow to Boeing as it represented the most important international fighter aircraft project since the Lightweight Fighter programme competition of the 1960s and 1970s, which had led to the F-16 Fighting Falcon and F/A-18 Hornet. At the time, the production run of the JSF was estimated at anywhere between 3,000 and 5,000. Boeing had to be content with work on the X-32 proving a strategic investment, yielding important technologies that it has been able to adopt in the F/A-18E/F Super Hornet and in other studies. On 3 May 2007 the Australian government signed a $2.9 billion contract to acquire 24 F/A-18Fs for the Royal Australian Air Force (RAAF) as an interim replacement for ageing F-111s. In September 2014 Boeing readied plans to close its St Louis

production lines for the Super Hornet and F-15 in 2017. With the fleet of KC-135 air tanker aircraft approaching the end of their operational life, on 24 February 2011 Boeing's KC-767 proposal (designated the KC-46A Pegasus) was selected for the KC-X tanker aircraft replacement programme over the Northrop Grumman-EADS (European Aeronautic Defence and Space Company) Airbus A330-200 submission. The initial contract would be for 179 aircraft for $35 billion to replace one-third of its Cold War-era KC-135 fleet.

Boeing and Airbus also locked horns with the development of the next generation of superjumbo jets. Airbus had in the planning stages the A-3XX, envisioned as the largest jetliner ever, with four engines, double decks running the length of the fuselage, a range of 8,800 miles and passenger capacity of 555–655. The project was estimated to cost $12 billion. Boeing envisioned a bigger, longer-range version of its 747 (747-x Stretch), with a seating capacity of 500 to 520, a range of 8,625 miles and a projected cost of just $2–$3 billion. By 2003 Boeing manufactured 350 aircraft per year – down from 600 in the 1960s. The company began taking orders for the 787 Dreamliner, a mid-range jet with speeds (Mach 0.85) that would match the fastest wide-body long-range planes but with vastly improved fuel efficiency, thanks to new Pratt & Whitney and Rolls-Royce high-bypass turbofan engines and a radically innovative body design. Roughly half of the primary structure of the 787, including the fuselage section and the wings, is made of carbon-fibre and plastic composite materials, lighter than the aluminium alloys used in most aircraft. Many airlines, faced with rising fuel costs, used the 787 to upgrade their fleets and ordered them in their hundreds with deliveries scheduled for commercial service in 2008. The 787 however, suffered production problems, not the least of which was failure of the crucial fuselage section in stress tests, and initial deliveries did not begin until 2011. In January 2013, following an airworthiness directive issued by the US Federal Aviation Administration (FAA), all 787s in operation globally were temporarily grounded until a potential risk for battery fire was corrected. Boeing continues to study the single-aisle 757 replacement market. Production of the 757 ended in October 2004 after 1,050 had been built for fifty-four customers. In July 2015 738 of the narrow-body twinjets were still in airline service. Airbus meanwhile looks to the long-range A321neo. Boeing will probably introduce a larger and longer-range aircraft between the single-aisle 737 MAX 9 and the twin-aisle 787-8.

In 2014 Boeing retained its title as the world's No. 1 aeroplane maker, delivering 723 aircraft compared to 629 from Airbus. Boeing's 2014 net sales were worth $233 billion while Airbus's total net sales were valued at $175 billion. This was because Boeing's sales involved bigger, more expensive wide-body commercial airliners, while Airbus has only the A330, A350 and some superjumbo A380s in the big jet category. The 737-strong workforce in Renton reached unprecedented levels of productivity in 2014, with up to forty-two jets produced per month. Airbus ended the year with 135 net new orders for wide body jets compared with Boeing's 328 or 63 per cent of wide body deliveries. It may be in the future that Airbus is positioned better for the smaller-jet market, because despite the huge success of the 737 MAX, the Airbus A320neo family continues to outsell it. Boeing has sold 286 of the MAX 9 jet. In comparison, Airbus had sold 755 A321s. The Boeing 777X family secured more than 240 orders into 2015.

The Chicago-based, $96.1 billion aerospace company with approximately 160,000 employees across the United States and in more than sixty-five countries was facing intense competition from Airbus, and 52-year-old Dennis A. Muilenburg, who became Boeing's chairman of the board and chief executive in March 2016, cut costs to help compete by cutting several thousand jobs in the huge commercial aeroplane division. Boeing will reduce 1,600 positions through voluntary layoffs, while the rest are expected to be done by leaving open positions unfilled. Despite a boost from military deliveries, the company was weighed down by investments in a tanker programme. Boeing delivered a record 762 commercial aircraft in 2015 and revenues climbed 6 per cent to an all-time high of $96.1 billion, but the aerospace group rattled investors by forecasting that it would not keep up that performance, with sales expected to slide to between $93 billion and $95 billion in 2016, and deliveries falling to as low as 740 jets. Boeing is the still the world's largest aerospace company and top US exporter. It is the leading manufacturer of commercial aircraft, military aircraft and defence, space and security systems; it supports airlines and US and allied government customers in more than 150 nations.

In the next decade competition between the big two on transatlantic routes and routes such as Europe to Asia, Europe to the Middle East and Australia to south Asia will be as hotly contested as ever.

1

DIVERSITY THROUGH ADVERSITY

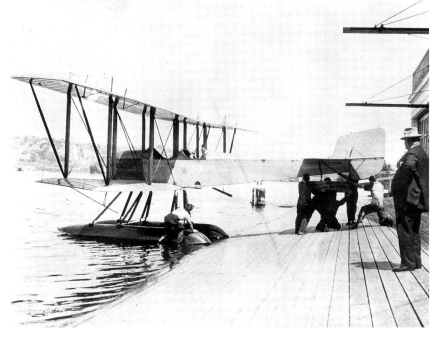

The XBLR-1 (XB-15), which flew on 15 October 1937, was a massive four-engined bomber that took three years to build, weighed more than 35 tons, and was almost 88ft long. It had a 149ft span and passageways were built inside the wing to enable the crew to make minor repairs to the four Pratt & Whitney R-1830-11 engines while the aircraft was in flight. Armed with six machine guns, it contained complete living and sleeping quarters with sound-proofed, heated and ventilated cabins.

One of the two B&W twin-float sport seaplanes of 1916 – Boeing's first aircraft. The original factory was a boathouse on Seattle's Lake Union. The aircraft workers were skilled carpenters, shipwrights, cabinet makers and seamstresses. The materials used were fine Washington State spruce lumber, steel wire and linen fabric.

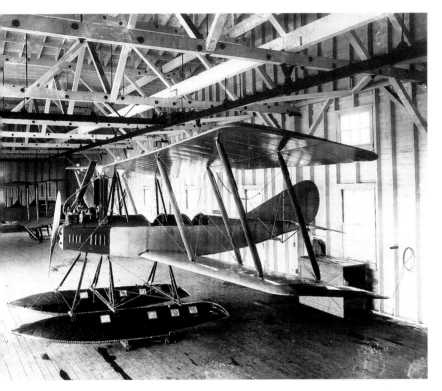

The Model 3 ('C' Series, C-4, 5, 6, 11) followed the B & W 1A and was the first 'all-Boeing' design. The US Navy ordered two Model Cs (5 and 6) for test from the Pacific Aero Products Co., which became the Boeing Airplane Company on 26 April 1917. Fifty additional Cs were ordered as US entry into the First World War created a sudden demand for primary training planes. Pictured in the boathouse on Seattle's Lake Union is the C-5, with clear-doped finish just prior to the new 1917 military tail striping being added. In the background is Mr Boeing's original Martin seaplane in the process of conversion to a land plane.

Fifty Model 5s (C-650-700, C-1F, CL4S), powered by a 100hp Hall-Scott A-7A, were ordered by the US Navy as primary trainers and these were serial numbered 650–699. A-650 is pictured in the boathouse on Lake Union on 22 April 1918.

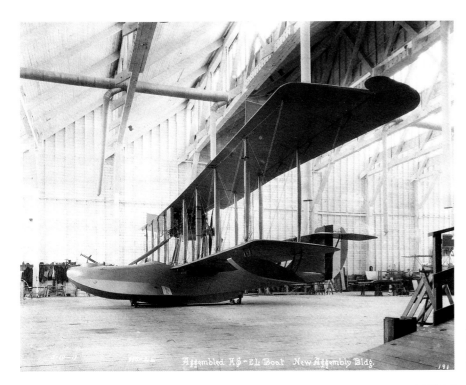

Although not a Boeing design, the single 360hp Liberty-engined Curtiss HS-2L patrol flying boat, fifty of which were built by Boeing, contributed significantly to production experience and added to the incentive to design the first post-war Boeing aeroplane, the B-1 flying boat.

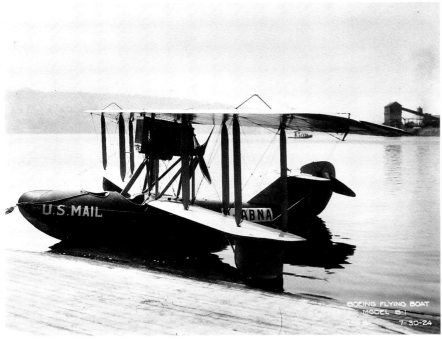

1B-1 (Model 6) flying boat was the first Boeing aeroplane designed from scratch as a practical commercial vehicle, and it first flew on 27 December 1919. Used continuously for eight years on the Seattle–Victoria airmail route, this single example was registered five times. N-ABNA was used from 1923–27.

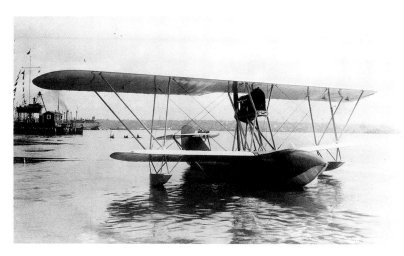

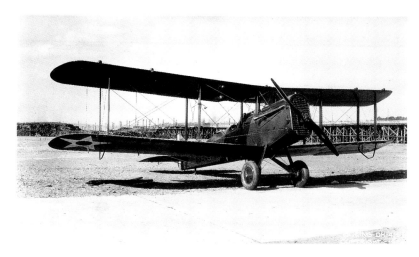

Single prototypes of the BB-1 (Model 7 – pictured), a smaller development of the B-1 which flew on 7 January 1920, and the BB-L6 (Model 8), a land plane using the same wings as the BB-1, were built but, like the B-1, never went into wider production, largely because of the flood of war-surplus machines that were available during the early 1920s.

After the First World War, Boeing subsisted mainly by modernising existing military biplanes. In 1920, Boeing rebuilt 111 wooden de Havilland 1916 design DH.4 'Liberty Planes' as DH.4b. From 1923 to 1925, 183 of the British two-seat day bombers were rebuilt with Boeing-designed steel tube fuselages as DH.4M-1 (for 'modernised'). Thirty of these were delivered to the US Marine Corps under the naval designation O2B-1, one went to the US Post Office, and six were delivered to Cuba.

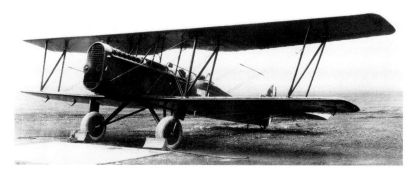

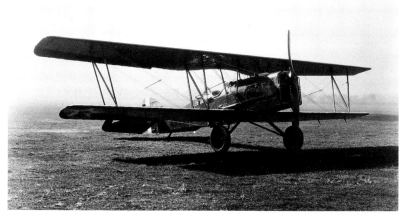

In 1924 Boeing responded to an AAC request to design and build new wings for three DH.4M-1s in an attempt to extend the useful life of the aircraft. The new Model 42 that resulted was called the XCO-7 (Experimental Corps Observation, design No. 7). The XCO-7A was powered by a Liberty engine.

The XCO-7B (pictured) differed from the XCO-7A in that it was powered by an army experimental inverted Liberty engine and it had balanced elevators. The Model 42 did not enter full-scale production.

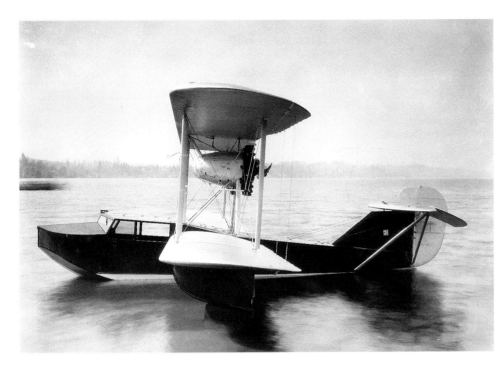

It was not until 1927–28, when war-surplus machine types had all but disappeared and commercial aviation was benefiting from the 'Lindbergh boom', that new types appeared. Two were the advanced versions of the B-1, known as the Model 6D (B1-D, pictured) and Model 6E (B1-E). The first of two B-1Ds flew in April 1928 and the first of six B-1Es flew on 4 March 1928.

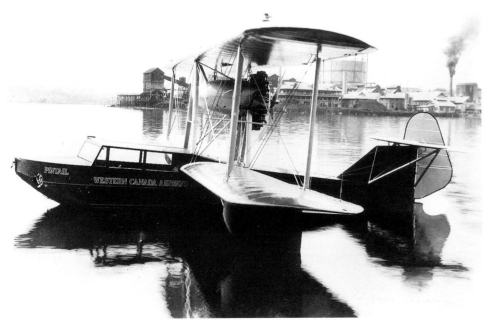

In 1929 subsequent production B-1Es were designated Model 204s because of the great design advances made since 1919. One was built, a second was completed as a dual-control 204A for William E. Boeing, the third was completed by a private owner, and four C-204 'Thunderbirds' were built by Boeing-Canada (including *Pintail*, belonging to Western Canada Airways Ltd, pictured).

Ten armoured GA-1 ground attack triplanes powered by two 435hp Liberty 12A engines were built under an early post-war policy whereby the army designed aeroplanes to its own requirements and then contracted out their manufacture by the aviation industry under competitive bidding. Although not a Boeing design, the GA-1, overweight and unpopular with cadets, which first flew in May 1921, was designated the Model 10.

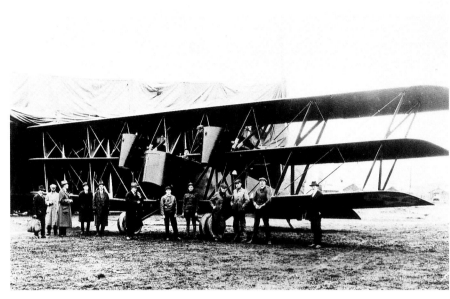

Two GA-2 biplane prototypes powered by an untried single 750hp Engineering Division W-18 engine were built by Boeing. Since the new engine was unavailable at the time of the contract, a wooden mock-up was delivered!

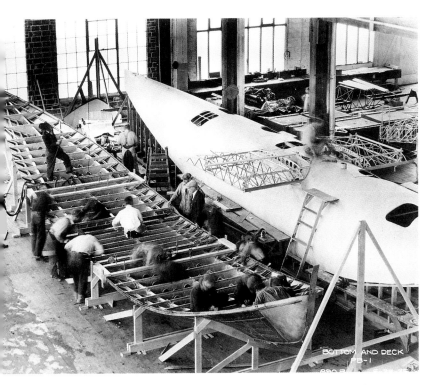

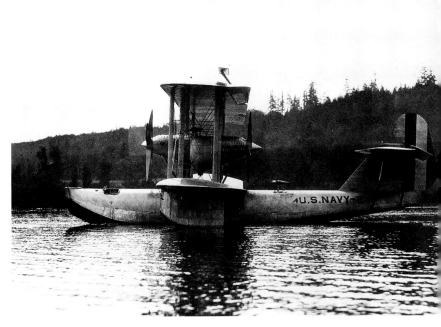

The Model 50 (PB-1) (P for 'patrol') built in 1925 resulted from a 1924 US Navy requirement for a flying boat capable of flying 2,400 miles from California to Hawaii non-stop. The construction material was primarily metal, although the upper portion of the hull (pictured) was of laminated wood frames covered with wood veneer, and the wing and tail covering was fabric.

The PB-1 designation was changed to XPB-2 (pictured) when the navy removed the tandem 800hp Packard 2A-2500 water-cooled engines and installed experimental Pratt & Whitney R-1860 Hornet air-cooled radials of 800hp. The PB-1 could carry 2,000lb of bombs or depth charges and various machine guns.

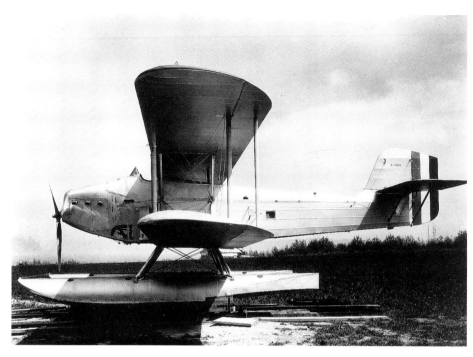

Three all-metal Model 63 aircraft (designated TB-1, T for 'torpedo', although the aircraft also doubled as a scout) were designed and built to US Navy specifications in 1927. These were powered by a 730hp Packard 3A-2500 and could be fitted out either as land planes for operation from carriers (the wings folded as a shipboard space-saving measure) or as twin-pontoon seaplanes. A-7024 (pictured), the first TB-1, flew on 4 May 1927.

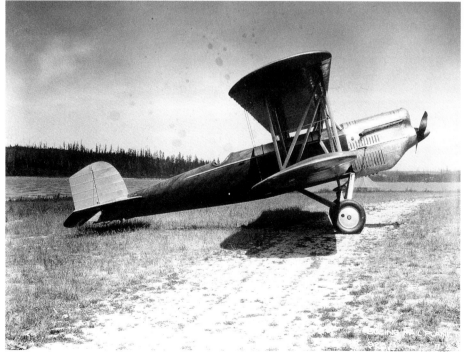

The Model 40 was built for a 1925 US Post Office Department competition to find a replacement for the converted military de Havilland DH.4s that had carried the airmail since 1918. The government purchased '775' (pictured), the single Model 40, but Boeing received no production contract. The Model 40A was revived in 1926 when indications were that the transcontinental mail routes would be turned over to private operators in 1927. The war-surplus water-cooled 400hp Liberty engine was replaced on the newly built aircraft by the 420hp Pratt & Whitney Wasp, a new air-cooled radial then being tested by the US Navy in the Boeing FB-6 and by Boeing in its new Model 69 fighter.

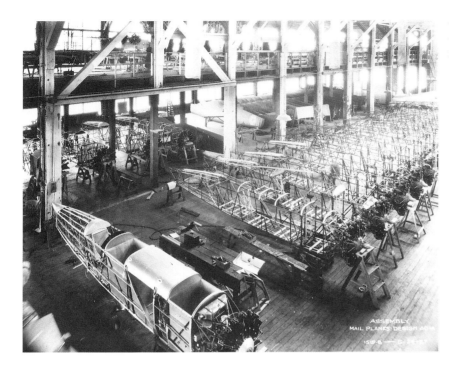

The composite wood-and-tube fuselage construction used on the Model 40 was changed to an all-steel structure on the Model 40A, pictured here on 24 May 1927.

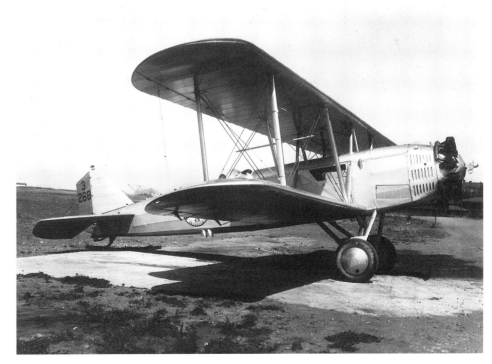

The lighter 420hp Pratt & Whitney Wasp engine permitted the Model 40A a greater payload, so that the basic design was further altered to include a two-seat cabin in the hope of attracting passenger revenue, in addition to the 1,000lb of mail that could be carried. The first of the Model 40As, 3268, is pictured.

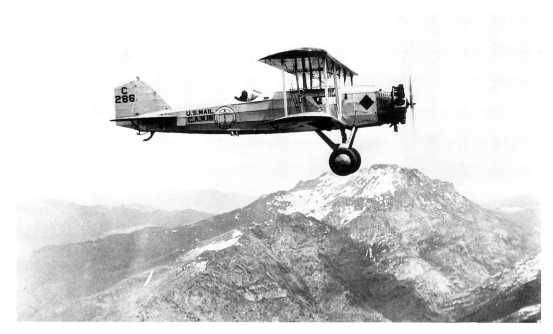

Twenty-four Model 40As were built for the airlines between January and June 1927 (C-286 is pictured). The Model 40A's low operating costs and high revenue-earning potential put the 40A in a class apart and Boeing Air Transport was able to submit the lowest bid for the San Francisco–Chicago route.

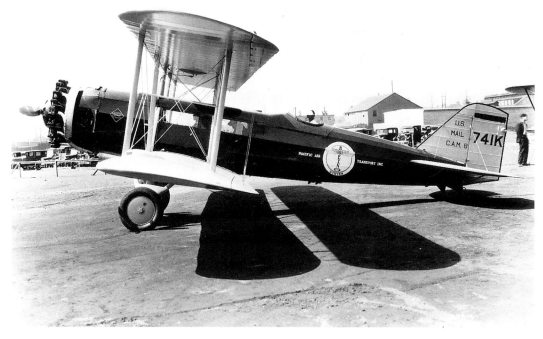

Model 40As were converted to Model 40Bs when a new 525hp Pratt & Whitney Hornet engine became available early in 1928. A Model 40C was developed simultaneously, using the Wasp engine but featuring a cabin for four passengers in place of the original two. Ten Model 40Cs were built, nine of them for Pacific Air Transport, which had become part of Boeing Air Transport. The major production series was the Model 40B-4, which combined the Hornet engine of the 40B and the four-place cabin of the 40C. Thirty-nine 40B-4s (including 741K, pictured) were built, and another was delivered to Pratt & Whitney in October 1929 as a flying test bed for the 650hp R-1860 Hornet engine. Altogether, eighty-two Model 40s were built.

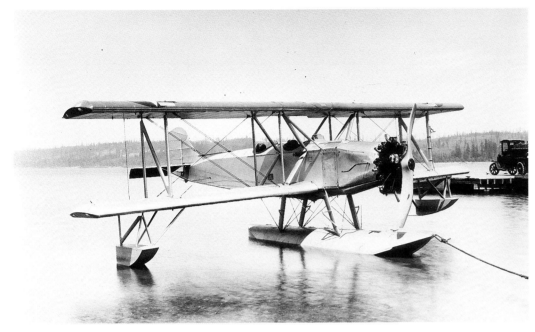

Starting in December 1924, forty-one NB-1s with 200hp Wright J series engines, and thirty as NB-2 with a war-surplus Wright-Hispano E-4 liquid-cooled engine of 180hp, were delivered to the US Navy. The Model 21 was designed to operate either as a land plane or as a seaplane using a single main float instead of the twin pontoons of the earlier Model Cs. Five Lawrence-engined Model 21s were also delivered to Peru: three in 1924 and two in 1927.

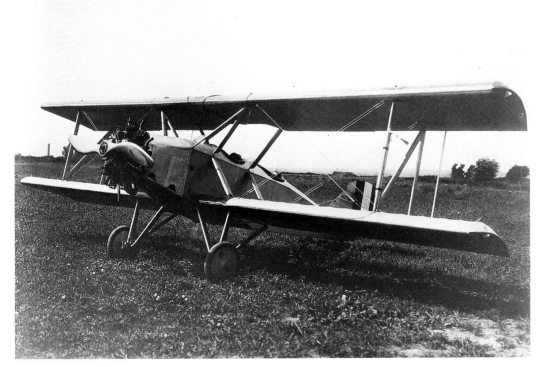

US Navy NB-1 prototype primary trainer (Model 21, A-6749 (518)), powered by a 200hp Lawrence J-1 air-cooled engine. The US Navy tested the first Model 21 extensively and found that it was almost too easy to fly and could not be spun. Changes to make the Model 21 'spinnable' had the opposite effect and the aircraft went into flat spins from which they could not recover!

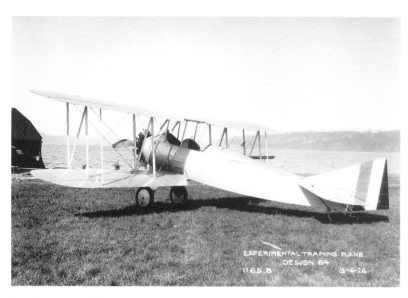

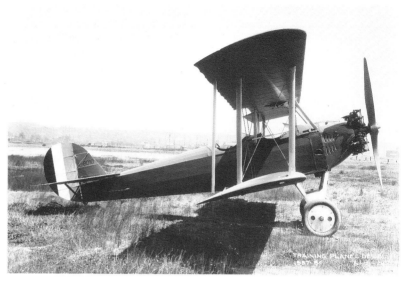

The Model 64, which first flew in February 1926, was designed as an improved land or sea primary trainer to replace the NB and was submitted to the army as a primary or gunnery trainer. A removable rear cockpit fairing structure permitted rapid change from gun ring to padded headrest.

XN2B-1, one of two Model 81s built in 1927–28 as a development of the Model 64, pictured on 18 May 1928. The XN2B-1 was built for the US Navy and the Model 81A for the Boeing School of Aeronautics. The original Fairchild-Caminez 125hp four-cylinder radial engine was replaced by a more conventional 165hp Wright J-6-5 (R-540) radial in January 1929.

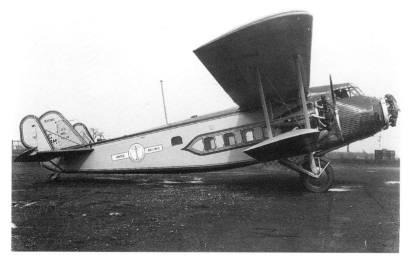

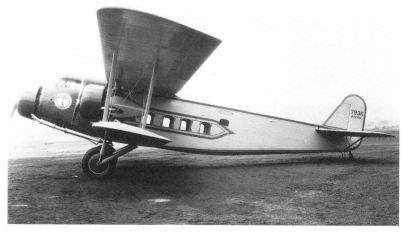

The success of passenger operations with Model 40s on the San Francisco–Chicago route encouraged expansion of the business through the addition of larger aircraft. Four Model 80 trimotor (410hp Pratt & Whitney Wasp) biplanes, which were designed specifically for passenger convenience and comfort, were built with a capacity of twelve passengers, the first being delivered to Boeing Air Transport in August 1928, just two weeks after its first flight.

The Model 80A (793K, the first, pictured) was an improved version, powered by 525hp Pratt & Whitney Hornets, and was capable of carrying eighteen passengers. Ten were built, the first two being delivered with fully cowled engines and the small vertical tail. The large passenger cabins on the Model 80 and 80A were provided with hot and cold running water, forced-air ventilation, leather upholstered seats, and individual reading lamps. The two pilots were enclosed in a roomy cabin ahead of and separate from the passenger cabin.

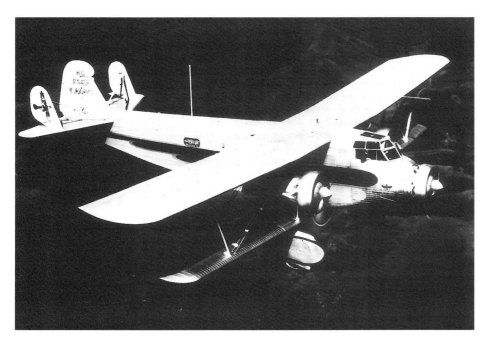

The eleventh Model 80A (NC233M) was completed as a deluxe executive transport (Model 226) for the Standard Oil Company of California, and the twelfth was constructed as Model 80B with an open cockpit (later converted to 80A-1 with an enclosed cockpit).

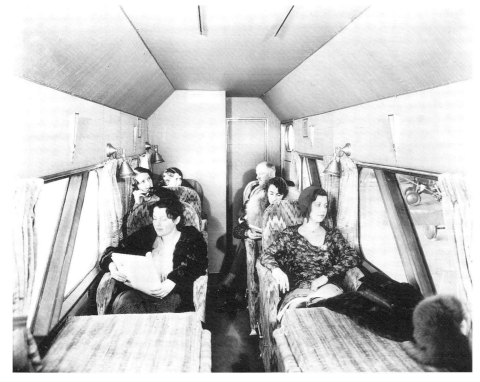

The luxurious cabin of the Model 226 executive transport, looking aft. All Model 80s became 80A-1s following service modifications that changed fuel capacity, streamlined engine cowlings, and added more rudder area.

Clockwise from right: With the Model 80s devoted almost exclusively to Boeing Air Transport's growing passenger service, a need arose for an all mail and cargo plane on the same routes. The first of twenty-five Model 95s, which made its maiden flight on 29 December 1928, were delivered on 18 January 1929. Of those with the traditional open-cockpit configuration (not all pilots liked the enclosed cabin as used on the Model 80) with 89 cubic feet of cargo space, twenty were delivered to Boeing Air Transport, one to National Air Transport, and four to Western Air Express.

Designed initially as a mail- and cargo-carrying plane, the Model 200 Monomail marked a radical new step in aviation when it first appeared on 6 May 1930. It was the first all-metal aircraft of monocoque construction and among its many innovative features was a single, smooth, all-metal low wing of clean cantilever construction, semi-retractable undercarriage, and the use of anti-drag cowlings on the 575hp Pratt & Whitney Hornet B power plants. A second Monomail, with a six-passenger cabin, was built as Model 221. This and the first model (NX-725W, later NC, pictured) were subsequently revised for transcontinental mail and passenger service and were re-designated Model 221A.

The Model 214 (Y1B-9) was a military development that applied the aerodynamic and structural concepts of the Monomail to bomber construction. Traditionally, bombers had until this point been biplane types, mainly of all-wood construction.

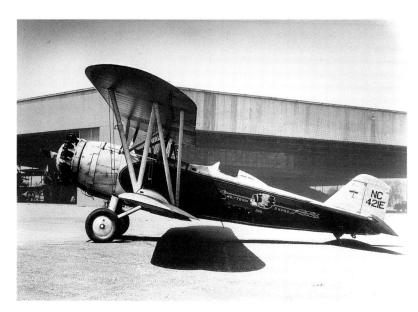

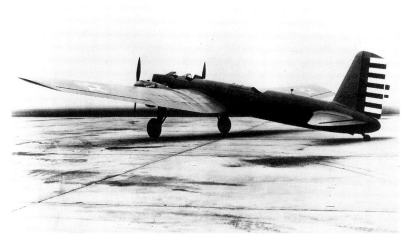

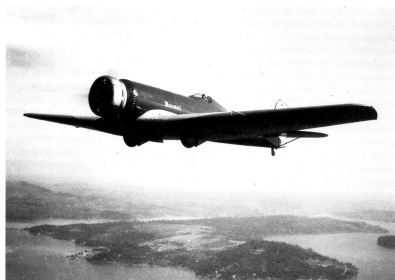

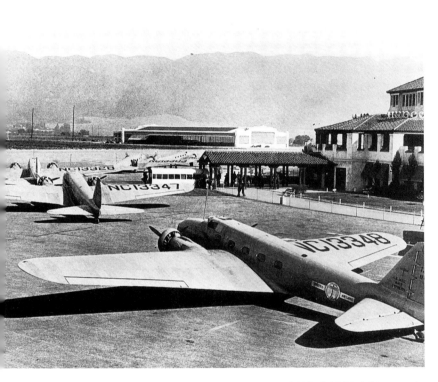

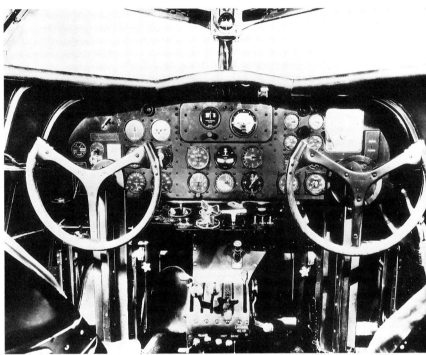

Boeing applied the B-9 design concept to the successful Model 247 civil transport whose final design was also influenced by the Monomail. An order for sixty Model 247s was placed while the design was still in the mock-up stage. The type flew on 8 February 1933 and featured retractable landing gear, an enclosed cabin, autopilot, trim tabs and de-icing equipment, and was powered by two supercharged Pratt & Whitney 550hp S1D1 Wasps (the first time superchargers had been used on a transport type). The original-style ring cowlings, small nacelles and fixed-pitch propellers are evident in this picture of five early Model 247s (NC13348, 13347, and 13328 nearest the camera).

Model 247 cockpit detail showing flight instruments (centre) and the engine and fuel system instruments in front of the co-pilot's control column (right). In 1934 Roscoe Turner and Clyde Pangborn in a 247D came third overall in the Melbourne Centenary Air Race between England and Australia, and second in the transport category.

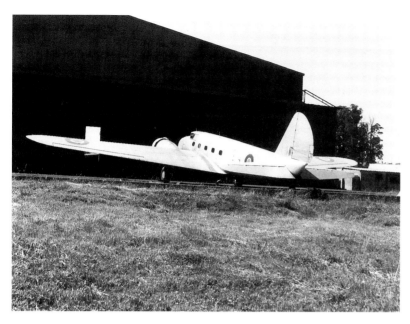

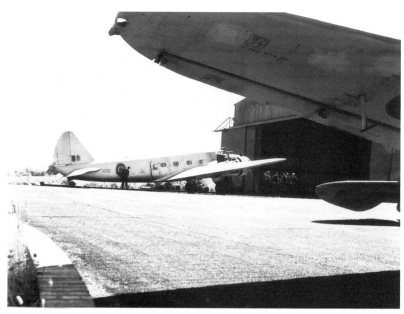

The 247D (C-73) was an improved version of the original Model 247 and thirteen were built. All US-operated 247s (two were delivered to Deutsche Lufthansa, the German national airline) were subsequently modified to 247D standard with improved Wasp S1H1G engines, full NACA cowlings, controllable-pitch propellers, and sloping windshields. C/n 1726 (pictured), formerly a Model 247, was one of eight 247Ds that served in the Royal Canadian Air Force (with RCAF serial number 7655), before being acquired by Britain and used by the RAF for research into instrument and automatic landing systems.

Here, the RAF roundels and serial number, DZ203, are being sprayed over. Traces of the wartime camouflage can be seen under the new scheme. Apart from the RCAF and RAF, the USAAC also operated twenty-seven 247Ds, between 1942 and 1944, under the military designation C-73.

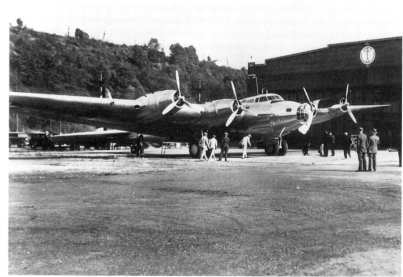

Right: Boeing, meanwhile, had entered the bomber business, as on 14 April 1934 the Army General Staff issued a request for design proposals for 'Project A', an aircraft capable of carrying a one 1-ton bomb 5,000 miles, to hit targets in Hawaii or Alaska. Boeing proposed the Model 294 (XBLR-1 – experimental bomber, long range), and on 28 June 1934 was awarded a contract for design data, wind tunnel tests and a mock-up. The XBLR-1 (35-277) was re-designated XB-15 by Edmund 'Eddie' T. Allen, test pilot and Director of Aerodynamics and Flight Research, before its first flight on 15 October 1937. (Allen was killed testing the XB-29 on 21 September 1942.) It was at that time the largest aircraft in the world. The XB-15 joined the 2nd BG in August 1938 and set a number of records.

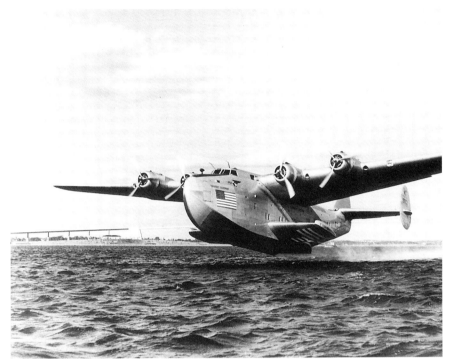

Early in 1936 the beautiful Model 314 was designed to meet a specification issued by Pan American Airways (PAA) for a long-range, four-engined flying boat capable of carrying seventy-four passengers and a crew of six to ten. The wing and horizontal tail surfaces of the XB-15, then under construction, were adapted almost intact to meet the requirement. Boeing signed an agreement on 21 July 1936 for six 314s, or 'Clippers' as they were known, and they were all delivered between January and June 1939. Pictured is NC18603 Yankee Clipper, operated for the US Navy in the Second World War by PAA.

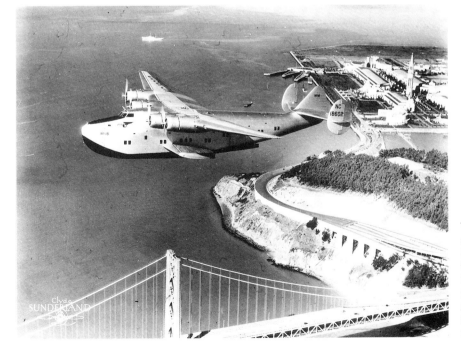

The first 'Clipper' flew on 7 June 1938 and began on transatlantic airmail service on 20 May 1939, and passenger service on 28 June. Six 314As for PAA with more powerful engines and provision for three extra passengers followed, and the first six 314s were brought up to the same standard. Early in the war, three were purchased by BOAC for operation on the Atlantic route, while three more were acquired by the US Navy and operated by Pan Am crews. NC18602 42-88632 California Clipper (pictured) was operated by the US Army in the Second World War. After the war the 'Clippers' were replaced by land-plane types.

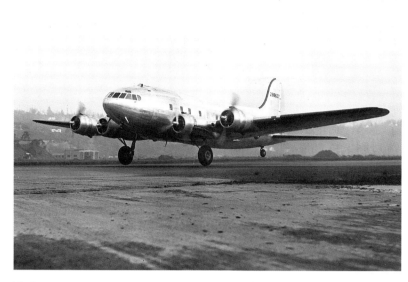

Work on the Model 300 transport ceased in 1934 when priority was given to the Model 299 bomber, but development was revived three years later in the Model 307, which utilised the wings, nacelles, engines, and original tail surfaces that were standard B-17 components, married to an entirely new fuselage. 42-88627 was one of ten Stratoliners built. The distinctive dorsal fin developed on this model was later used on the B-17E.

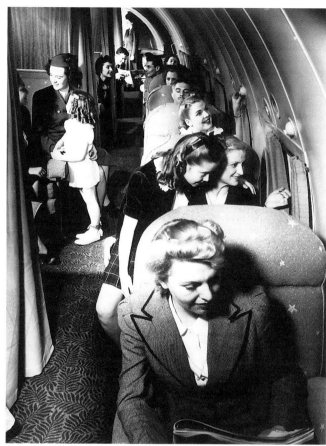

Above: An outstanding feature of the 307, thanks to its circular cross-section, was its first use of cabin pressurisation for passenger comfort at sub-stratospheric altitudes. The design also permitted maximum room for thirty-three passengers and five crew, including, for the first time, a flight engineer. After the war the revamped Stratoliners, now fitted with replacement B-17G components, could carry thirty-eight passengers.

Left: In 1937 ten Stratoliners were ordered by US airlines: four PA-307s (S-307) by PAA (including NC19903, pictured above), five SA-307Bs by Transcontinental and Western Air (TWA, now Trans World Airlines), and a single SB-307B by Howard Hughes. The first 307, an S-307 for PAA, flew on 31 December 1938, but was lost on a subsequent test flight. The S-307s remained in Pan Am service until the end of the Second World War but in 1942 all five SA-307Bs were impressed into Army Air Transport Command service as the C-75. In 1944 they were returned to the factory for conversion back to airline standards as SA-307B-1s.

IN PURSUIT OF PERFECTION

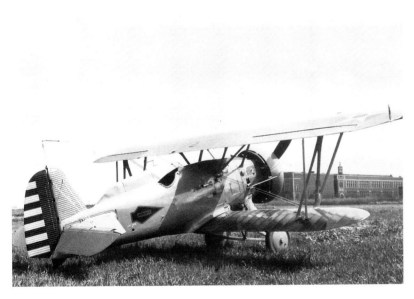

Some 586 aircraft in the P-12/F-4B series were delivered to the army and the navy (and a few overseas); the last was on 28 February 1933.

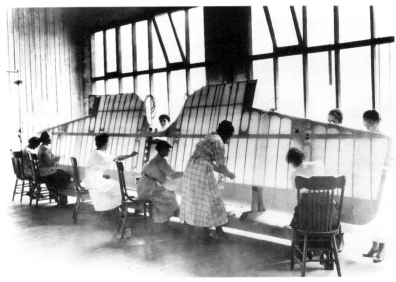

Women workers stitching the upper wing fabric of an MB-3A. In 1921, Boeing was the lowest bidder among six manufacturers competing for an army contract for 200 Thomas-Morse MB-3A pursuit planes. This was the first sizeable order for new aircraft placed by the military since the Armistice and it provided the company with design experience that saw Boeing become the leading American supplier of single-seat pursuit aircraft between 1924 and 1936.

Clockwise from right: This Thomas-Morse MB-3A pursuit plane came to grief on 7 June 1922.

Financed as a private company venture, the first Boeing pursuit, the Model 15 (XPW-9 – Experimental Pursuit, water-cooled design No. 9), flew on 2 June 1923.

Model 15, 23-1217, the second XPW-9 prototype, showing the indented upper wing leading edge and the streamlined cross-axle landing gear of 16in cord used on all three examples.

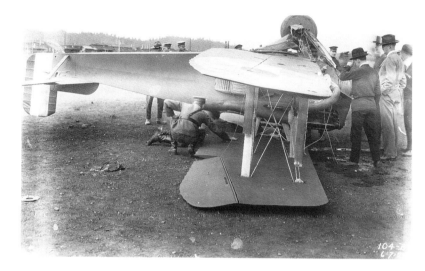

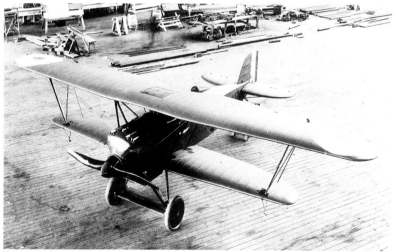

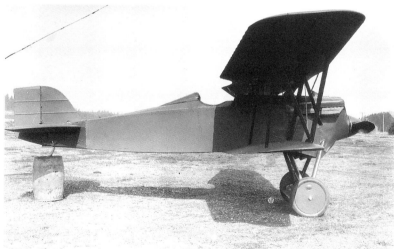

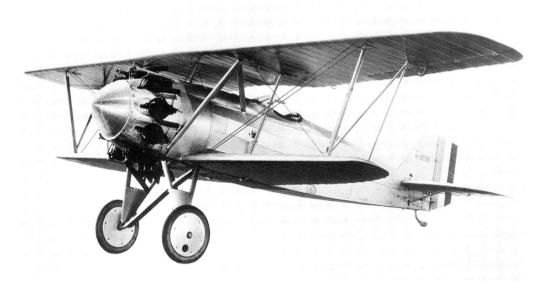

Two FB-2s, modified to operate from aircraft carriers, were designated Boeing Model 53 because of the design changes. Three FB-3s with Packard engines (Model 55) and one FB-4 (Model 54) (pictured, on 15 January 1926) with an experimental Wright 450hp air-cooled P-1 radial were delivered for test. Twin wooden floats were fitted and after delivery the navy converted the FB-4 to FB-6 by changing the P-1 engine for a Pratt & Whitney Wasp radial.

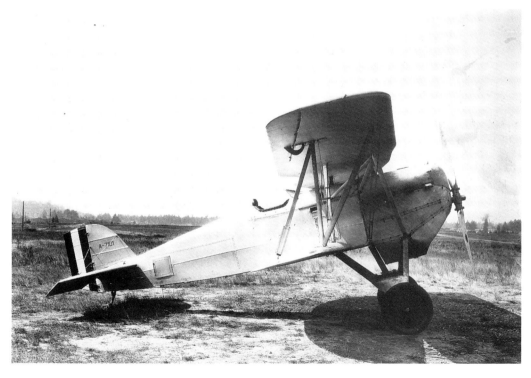

The navy ordered twenty-seven production FB-5s (Model 67) powered with the 520hp Packard 2A-1500. The first flew on 7 October 1926.

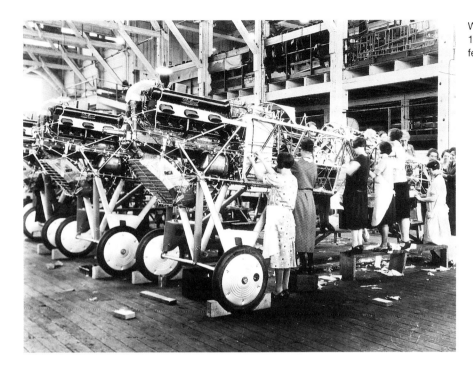

Women workers covering the fuselage of an FB-5 with fabric, 13 January 1927. All twenty-seven FB-5s were delivered on 21 January 1927, being ferried by barges directly to the carrier *Langley* in Seattle harbour.

Assembly of mail planes, and PW-9C pursuits (left). Production experience with the MB-3As and careful study of the newest aerodynamic and structural concepts convinced Boeing engineers that they could produce a better pursuit plane than anything then available. The principal source of dissatisfaction with the MB-3A was the wooden fuselage. Welded steel tubing had been used successfully during the First World War. The gas welding process with hand torches had disadvantages, so Boeing developed an arc welding process. The new fuselage construction was so successful that the army gave Boeing additional DH.4 modification contracts that called for replacement of the original wooden fuselages with steel.

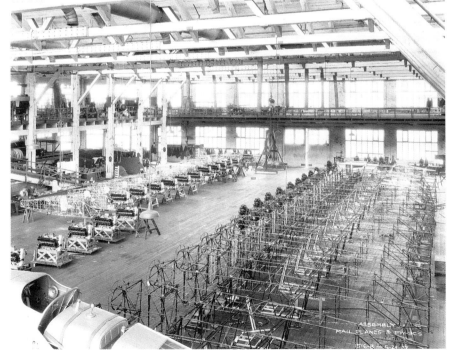

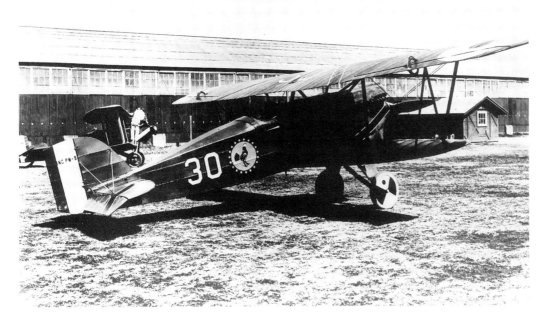

Altogether, 123 PW-9s (including 25-301, pictured) were delivered, ending with the PW-9D (Model 16D) of 1928. The XP-7 (Model 93, pictured) was the last PW-9D, which was re-designated when fitted temporarily with a new 600hp Curtiss V-1570 engine.

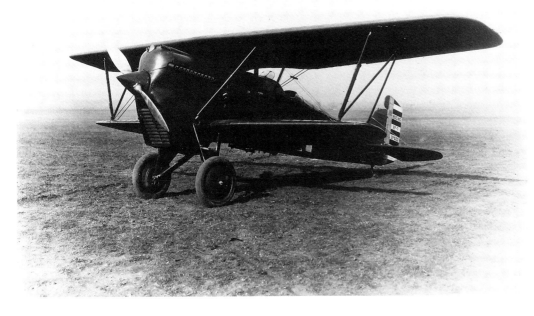

The US Navy ordered sixteen PW-9s for shore-based duties with the marine corps but only ten (including A-6893, pictured) were delivered, in December 1925, under the naval designation of FB-1, for Fighter, Boeing. Nine of these served with the USMC Expeditionary Force in China in June 1928.

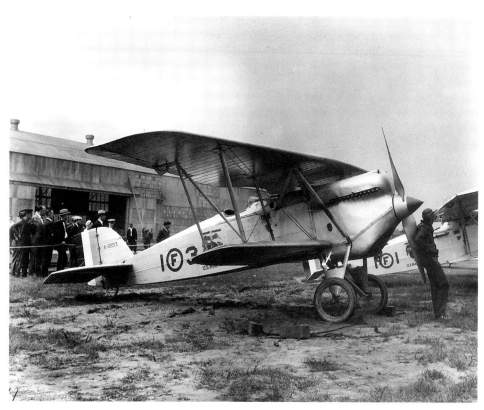

The F2B-1 was a direct development of the PW-9/FB series, designed to use the 425hp Pratt & Whitney Wasp engine designed by the navy in the FB-6. In addition to the prototype XF2B-1, the navy bought thirty-two production F2B-1s for use on aircraft carriers.

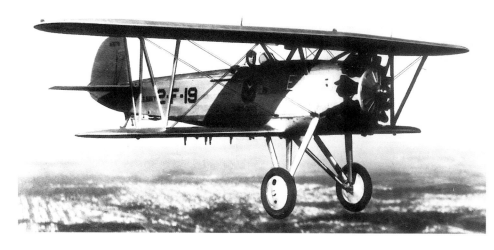

The XF3B-1 which flew on 2 March 1927 was offered as an improved fighter version of the F2B-1 with new, larger wings, but it was only when it re-emerged as a fighter-bomber (Model 77) that it was taken up by the navy. A contract for seventy-three F3B-1s, each with a P&W R-1340 Wasp engine, followed.

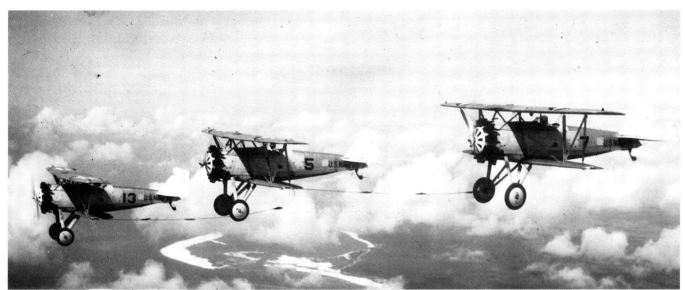

The three F-2B-1s of the Sea Hawks, the US Navy's first precision aerobatic team, performing their characteristic tied-together aerobatics. The team would take off, manoeuvre and land with their wing tips joined by 50ft lengths of rope, which had streamers attached to improve visibility from the ground. Eventually a whole squadron of F-2Bs was able to fly and land tied together!

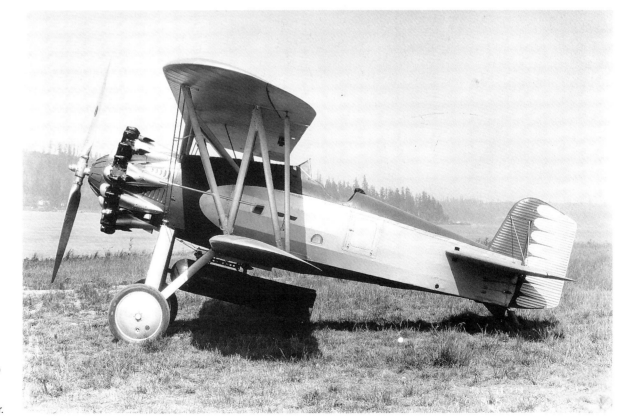

Early in 1928 all Boeing's fighter plane experience culminated in two new prototype pursuits, the Model 83 (navy XF4B-1 No. 1), which first flew on 25 June 1928, and the Model 89 (navy XF4B-1 No. 2, pictured carrying a 500lb bomb under its belly), which flew on 7 August. The F4B was a dual-purpose design, as both fighter and dive bomber.

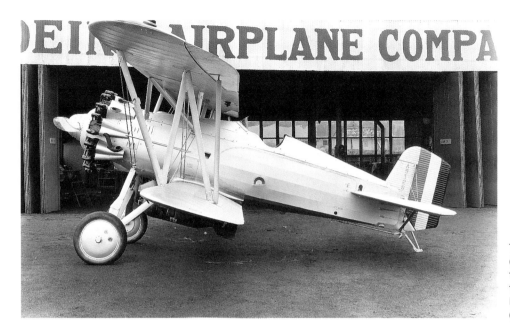

The first XF4B-1 was reworked to production configuration (A8129, pictured on 17 June 1929) and delivered to the navy as the second article on the F4B-1 (Model 99) contract. Following the XF4B-1 tests, the navy ordered twenty-seven production F4B-1s (A-8130/8156), and the army ordered nine identical P-12s (Model 102) and one as XP-12A (Model 101).

Wooden wings, bolted aluminium tube fuselage and corrugated control surfaces of the P-12 are evident in this uncovered view.

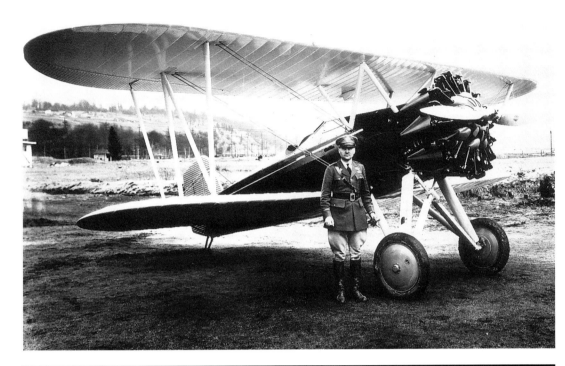

P-12 29-353 Pan American, the first army Model 102 built, was turned over to Captain Ira C. Eaker on 26 February 1929, shortly after his famous 150-hour endurance flight.

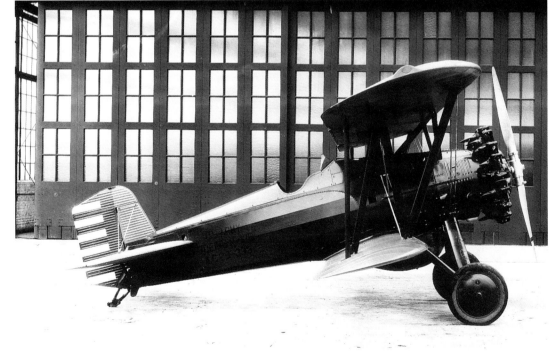

In 1929 ninety examples of the Model 102B (P-12B; 29-333 is pictured) were ordered, the largest single army order for fighters since 1921. The optional 55-gallon auxiliary fuel tank is fitted under the belly.

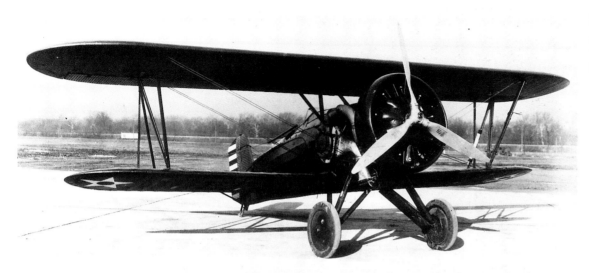

AAC 29-329, the first P-12B, was modified by the AAC as XP-12G to test turbo-superchargers and ring cowlings and was fitted with a three-bladed prop to absorb the additional power, before reverting to P-12B.

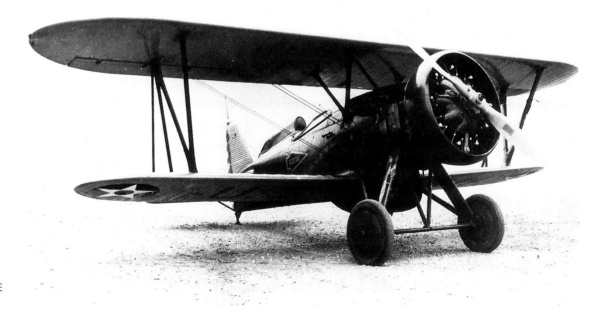

The last twenty-five P-12Es were completed as P-12Fs (Model 251), while 32-42 (pictured) became the P-12J when it was used at Wright Field to test a supercharged Pratt & Whitney SR-1340H engine and a special bomb sight. Later it became a YP-12K to test the SR-1340E fuel-injected engine, before reverting to P-12E.

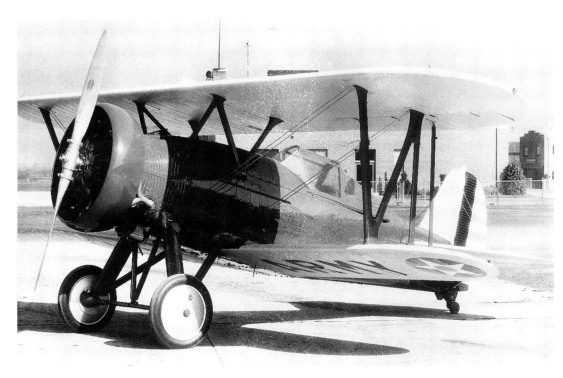

P-12F (32-101), the twenty-fifth and last of the production run, was fitted with an experimental enclosed cockpit canopy and is pictured on 11 May 1932, six days before delivery.

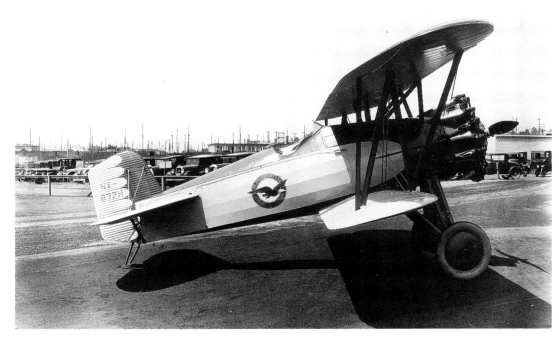

Four commercial and export derivatives were developed as Model 100s and a special two-seat 100A was built. NX872H (pictured) was sold to Pratt & Whitney for use as a flying test bed.

Model 218 (XP-925, 925A) X-66W was a Boeing-owned aeroplane used to test new features for the P-12/F-4B series and first flew on 29 September 1930. It was sold to China after US testing and, flown by American volunteer pilot Robert Short, is reported to have destroyed two out of three attacking Japanese fighters before being shot down over Shanghai in 1932.

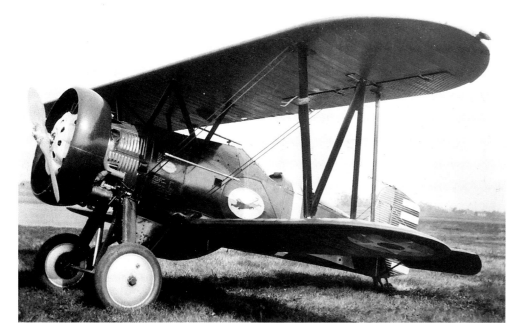

The Model 227 (P-12D, XP-12H) resulted from slightly modifying the last thirty-five of the original 131 aircraft in the P-12C order. Deliveries began on 25 February 1931 and finished on 28 April.

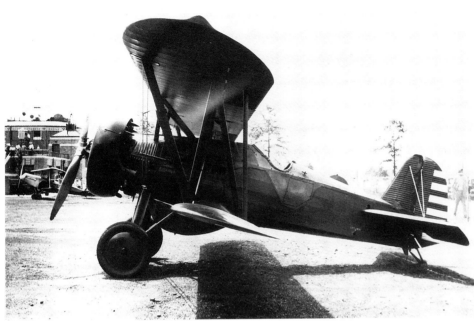

The thirty-third P-12D (31-273) was re-designated XP-12H when the AAC fitted it with an experimental geared Pratt & Whitney GISR-1340E engine but this proved unsatisfactory and the plane was reconverted to a P-12D in June 1932.

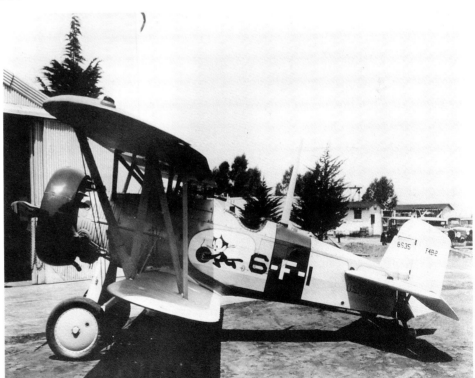

F4B-2 (Model 223) 8635 of VF-6B (later, VF-3) with the famous 'Felix the Cat' with a bomb in his claws. The US Navy ordered forty-six F4B-2s and the first was delivered on 2 January 1931, the last on 2 May.

On 3 March 1931, the AAC ordered 135 P-12Es (Model 234) (32-44 pictured). The enlarged 'Panama' headrest contains a life raft.

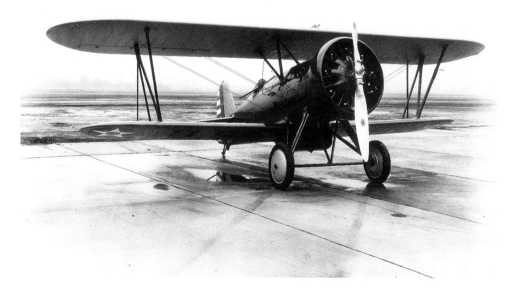

P-12E (Model 234) pictured on 19 September 1931.

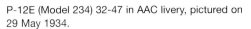

P-12E (Model 234) 32-47 in AAC livery, pictured on
29 May 1934.

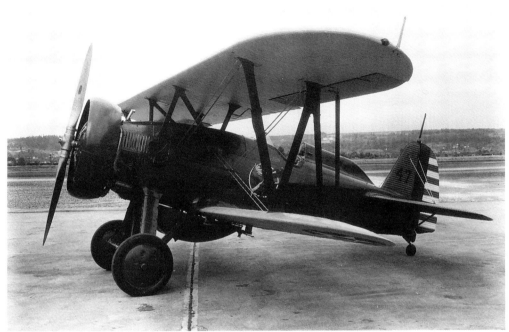

The US Navy followed with an order on 23 April 1931 for 113 similar
Model 235s, twenty-one of them as F4B-3s. The F4Bs were first
delivered to the Marine Corps VF-9M (East Coast), and were soon
followed by delivery to VF-10M (West Coast) in late 1932. Pictured
are three of VB-10M Bombing Squadron 4's F4B-3s in 1933 after the
squadron's changeover from Fighting Squadron 10.

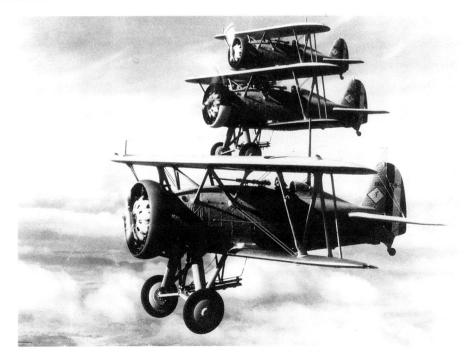

Clockwise from right: In addition, ninety-two Model 235s, like this VF-5 (Fighting Squadron 5) machine, were ordered as F4B-4s, which had larger vertical tail surfaces.

Fourteen of the original F4B-4s were diverted from the US Navy order and modified slightly for delivery to Brazil (called 1932 – Model 256) as land-based fighters between 14 September and 9 October 1932.

Five Model 203 primary trainers, powered by 150hp Axelson engines (the third with the original small tail and Axelson engine is pictured on 25 October 1929), were built for the Boeing School of Aeronautics. All were converted to the 203A type by installation of 165hp Wright J-6-5 Whirlwind engines.

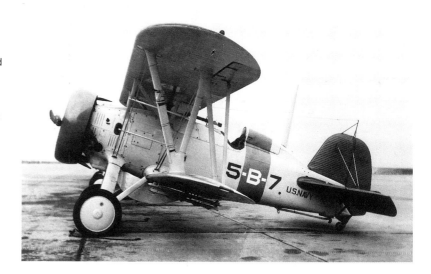

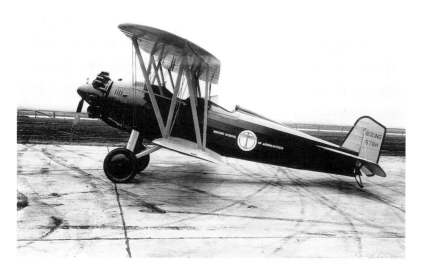

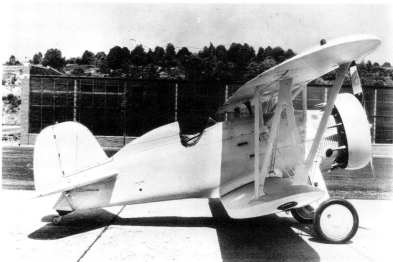

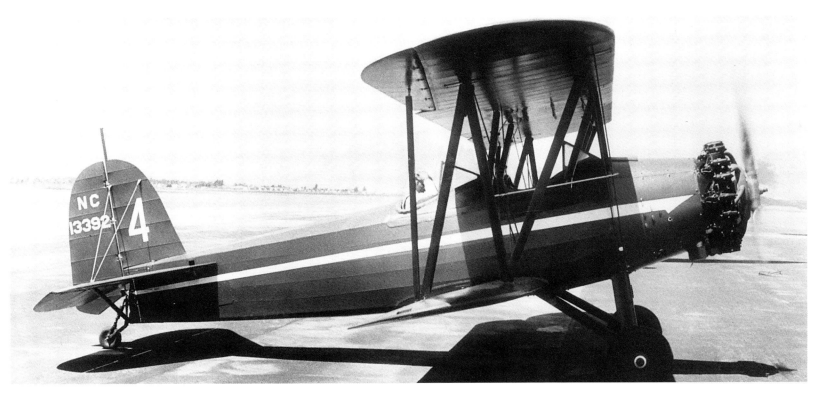

Two additional Model 203s were built by students at the school. They were later converted to 203As with the change to the Wright engine: NC12748 in 1935 and NC13392, pictured, in 1936. Three 203As were converted to 203B advanced trainers with 220hp Lycoming engines.

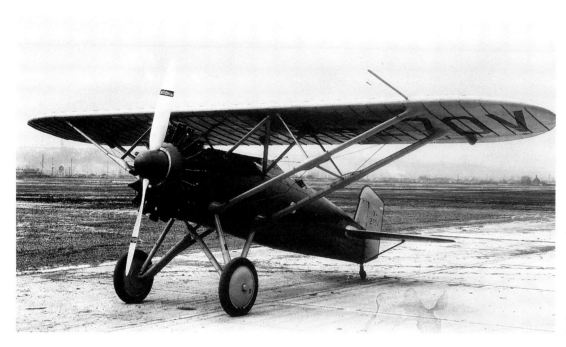

With the biplane fighter era almost at an end in 1930, Boeing submitted Models 202 (XP-15) (pictured), and 205 (XF5B-1), almost identical all-metal monoplane versions of the established P-12/F-4B, to the AAC and US Navy. While neither was ordered into production, the new semi-monocoque fuselage structure was used on later versions of the P-12/F-4B.

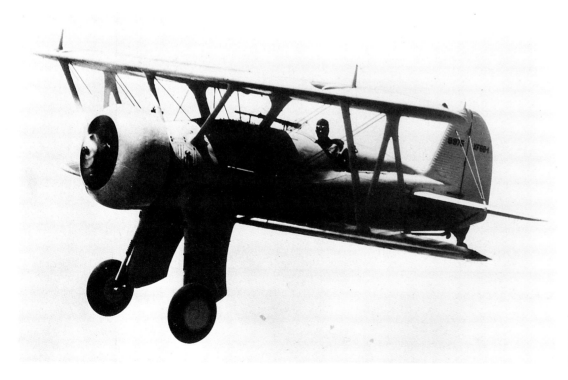

The Model 236 (XF6B-1) was developed as a possible successor to the F4B-4, but the era of the classic biplane fighter with fixed landing gear was over and the type did not enter production.

Boeing's Model 248, which first flew on 20 March 1932, was the first all-metal monoplane fighter. Boeing built three prototypes (designated XP-936, pictured) at its own expense but the army loaned Pratt & Whitney 522hp SR-1340E Wasp engines, instruments, and military equipment for the project, which was carefully co-ordinated with the army to ensure its requirements were met.

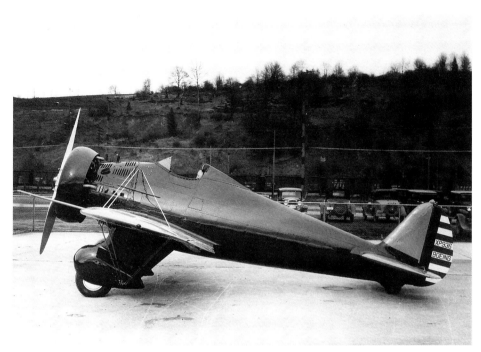

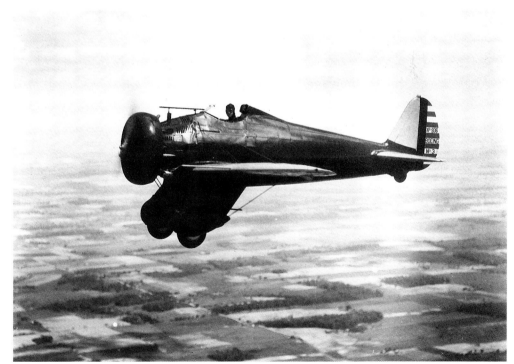

The third XP-936, which went to Selfridge Field, Michigan, where it was tested by the army. During service tests the XP-26s became Y1P-26 and finally plain P-26. After testing, the army purchased the XP-936s as XP-26 on 15 June 1932.

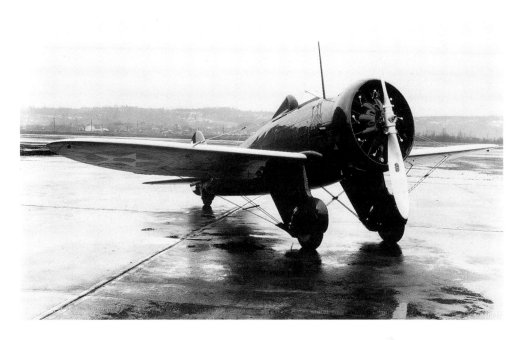

P-26A pictured on 16 December 1933. A total of 111 P-26As were ordered by the AAC. Their top speed was 222mph, 27mph faster than the P-12F, but at 30,700ft they fell 800ft short of the biplane's absolute ceiling.

Twelve export versions, eleven for China and one for Spain, were built as the Model 281. Lt José Kare, in one of nine P-26As turned over to the Philippine Army late in 1941, shot down a Japanese Zero fighter during their attack on the Philippines. Here, Captain Jesus Villamor enters his P-26 fighter during a December 1941 alert. This photograph was present in many Philippine homes during the Japanese occupation.

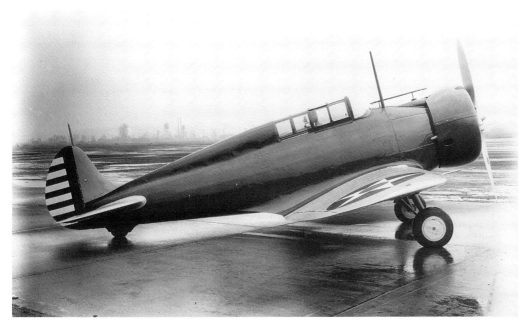

Boeing cleaned up the P-36 design by adopting cantilever wing construction to remove the need for a wire-braced wing, and fitted a retractable undercarriage. Two models were developed simultaneously for the AAC and the US Navy, the former being designated YP-29, formerly the XP-940 (Model 264, pictured on 17 January 1934). In March the XP-940 was returned to the factory for modification and became the YP-29A.

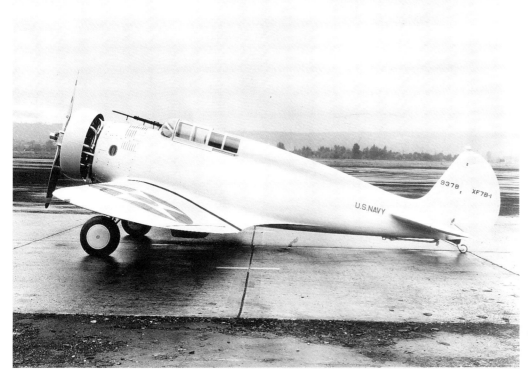

The XF7B-1 (Model 273, pictured on 14 September 1933), similar to the XP-940, first flew in September 1933. It was the first low-wing monoplane fighter tested by the navy.

The second Model 264, designated YP-29 because of the purchase contract having been signed following testing of the XP-940, was completed with a large and roomy glasshouse enclosure around the cockpit.

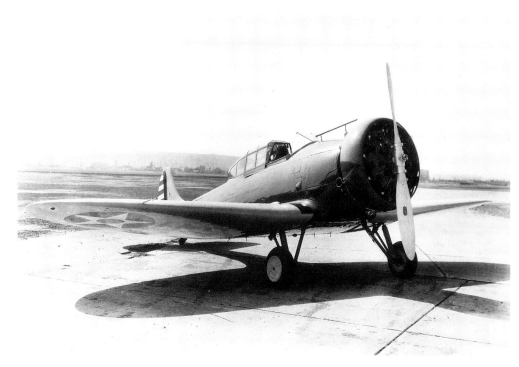

The original cockpit enclosure of the XP-940 was replaced by an open cockpit and a redesigned headrest and the aircraft became YP-29A (pictured) when purchased by the army. Although 16mph faster than the P-26A, the YP-29A's greater weight restricted manoeuvrability and its service ceiling, and the intended P-29A production order never materialised.

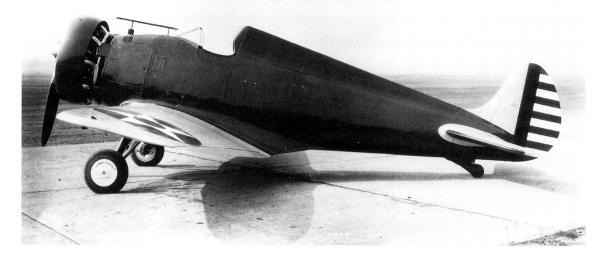

3

BIG ASS BIRDS

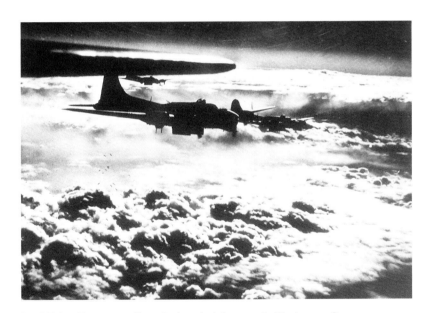

B-17 Flying Fortresses silhouetted against the sun at altitude over Germany.

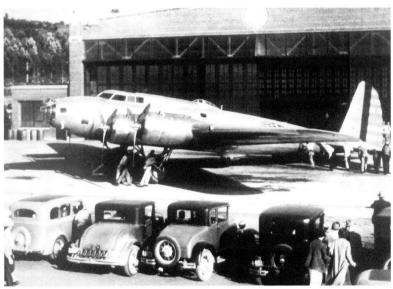

X13372, the Model 299, shown here at its roll out at Boeing Field, Seattle, 17 July 1935 when, because its wingspan was greater than the width of the hangar door, it had to be rolled out sideways on wheeled dollies. The Model 299 was flown for the first time on 28 July by the company test pilot, Leslie Tower.

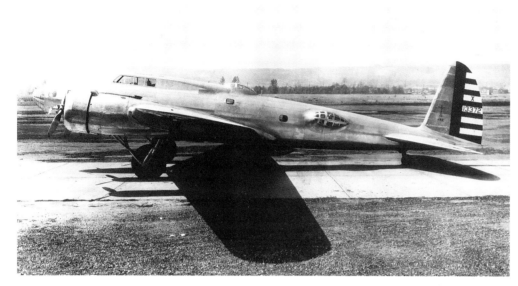

The clean lines of the Model 299 owed much to the sleek Model 247 airliner, which was scaled up into the much bigger bomber by using many of the engineering innovations that had been developed on the earlier Model 294 (XB-15) project.

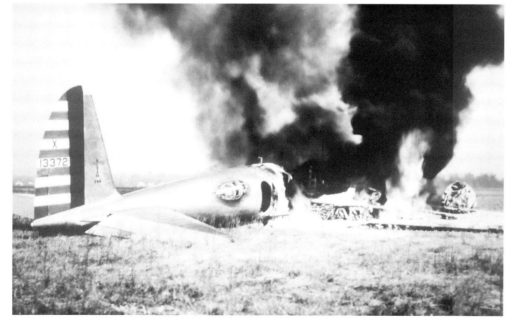

Testing was almost complete and the air corps about to confer the title XB-17 on the Model 299 when, on 30 October 1935, the aircraft crashed with Major Ployer P. 'Pete' Hill (chief of Wright Field's Flight Testing Section) at the controls. Hill died later that day and Leslie Tower, Boeing test pilot, died a few days later. The subsequent investigation concluded that the crash was a result of the mechanical ground locks not having been unlocked prior to take-off.

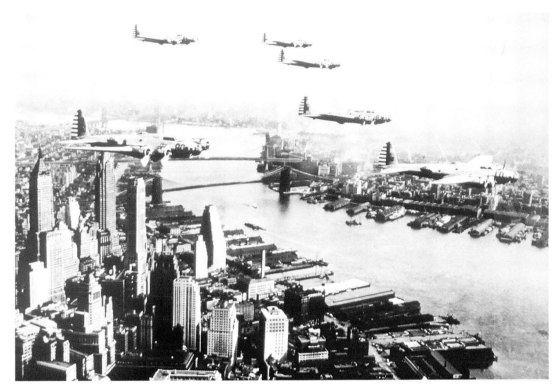

Ill luck also dogged the Y1B-17 service test machine development. The first Y1B-17, 36-149, was rolled out on 30 September 1936 and it flew for the first time on 2 December, but on the 7th it nosed over during landing. However, the thirteen service test Y1B-17s went into service with the 2nd BG, at Langley Field, Virginia, from March to August 1937, and were flown 1.8 million miles over land and sea without a problem. Six of the Y1B-17s that made a goodwill flight to Buenos Aires, Argentina, in February 1938 are pictured over New York City. They covered a total of 12,000 miles without serious incident. The Fortress's place in history was assured.

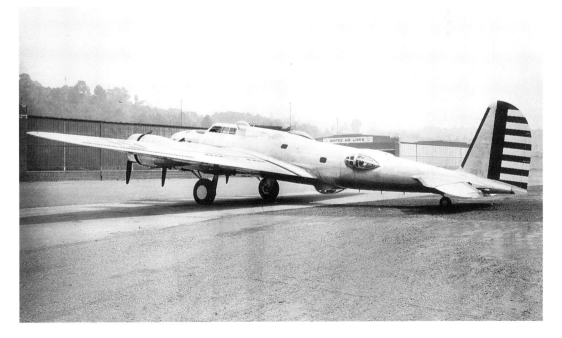

The hoped-for large production contracts for the B-17B (Model 299E, later Model 299M) were slow in coming. A requirement for ten B-17Bs had been received on 3 August 1937 and by 30 June 1938 orders stood at just thirty-nine. Problems with the superchargers, which tended to fail very frequently, meant that the first B-17B (38-211) did not fly until 27 June 1939. The first B-17Bs were delivered to the AAC between October 1939 and 30 March 1940. In 1940–41 many B-17Bs were revamped and fitted with new devices such as flush-type waist windows for .50 calibre guns.

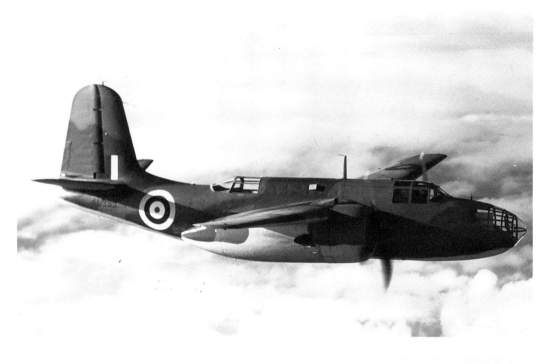

Fortuitously for Boeing, on 18 May 1940 the company received a very timely contract from the French government to build 240 Douglas DB-7B (A-20C) attack bombers under licence. When completed, the fall of France meant that these (including AL399, pictured) were delivered to England as Boston IIIs. Some were diverted to Russia. Night fighter conversions became Havocs. A further 140 A-20Cs were constructed for the USAAC.

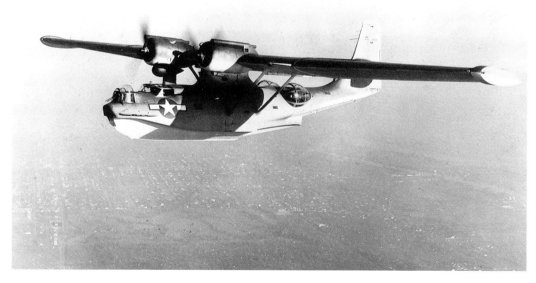

Meanwhile, the Boeing Canada plant at Vancouver, British Columbia, which had produced Blackburn Shark III torpedo planes for the RCAF in 1938 and 1939, was expanded to undertake aircraft repair and conversion. Also produced were fifty-five Consolidated PBY-5A Canso amphibians for the RCAF and 307 PBY-5 and -6 Catalina flying boats under the US Navy designation of PB2B-1 (pictured) and PB2B-2 for the US Navy and British Empire services.

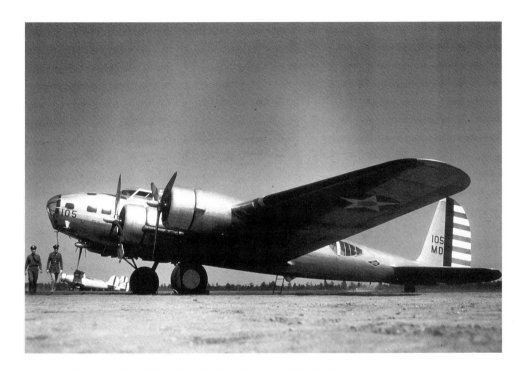

Only eighteen B-17Cs (Model 299H) were ordered, on 10 August 1939, for the AAC and it was not until April 1940 that the army finally exercised its option for forty-two more. Meanwhile, twenty Model 299U/B-17Cs (Fortress Is) were ordered by Britain for the RAF from the 1939 contract. The B-17C first flew on 21 July 1940.

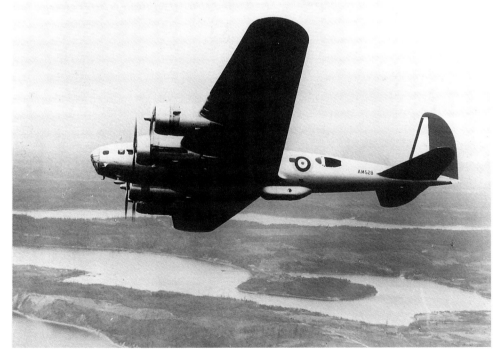

Fortress I (40-2064), which became AN528 'B-Baker' in No. 90 Squadron RAF, pictured during an early test flight. (At first, the Fortress Is for the RAF had 'AM' serial letters applied in error but they were changed later to 'AN'.) RAF Forts first went to war on 8 July 1941, when three bombed Wilhelmshafen. 'B-Baker' had joined 90 Squadron on 4 June but caught fire running up her engines at dispersal at Polebrook on 3 July and was burnt out.

Forty-two B-17Cs, which had been ordered on 17 April 1940, required so many modifications, mostly due to combat experience in Europe by the RAF, that on 9 September 1940 they were redesignated as B-17Ds. More armour plate was added and armament doubled in the ventral 'bathtub' and upper positions, while additional sockets were added for the .30 calibre nose gun, making seven guns in all. Self-sealing fuel tanks were installed and the bomb release system was redesigned.

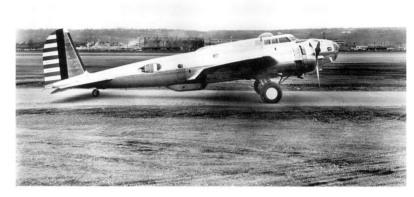

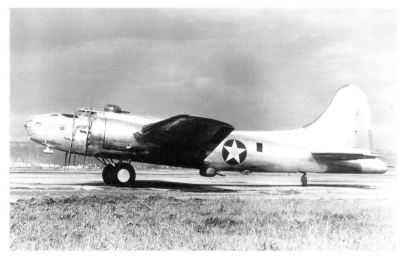

Finally, on 12 July 1940, Boeing was advised by the War Department that orders for 512 more B-17s would be raised, but material shortages delayed production of the B-17E and the example did not make its maiden flight until 5 September 1941, four months behind schedule. Boeing received orders for 812 B-17Es but after 512 had been built, the remaining 300 aircraft were converted to B-17F production.

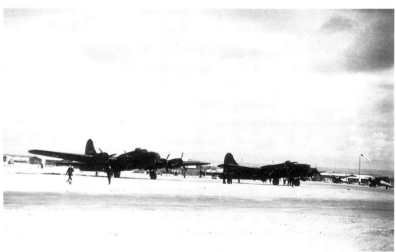

B-17Es 41-2459 and 41-2461 at Shallufa, Egypt, en route to join the 19th BG in Java. The 19th fought a brave but losing battle in the Philippines after the Japanese invasion. 41-2459 and 41-2461 were first used in action on 16 January 1942. Lt J.L. 'Duke' Du Frane's and Maj. C.F. Necrasson's respective crews had to force land at Kendari, Borneo, and were strafed by Zeros. Du Frane's B-17 was disabled but his crew escaped and were later evacuated to Java. The aircraft was later blown up during the US retreat.

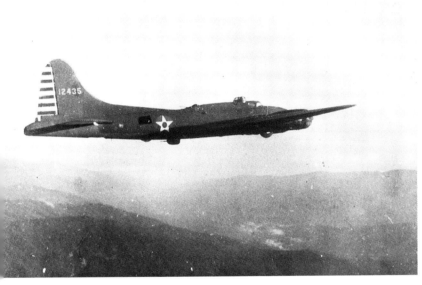

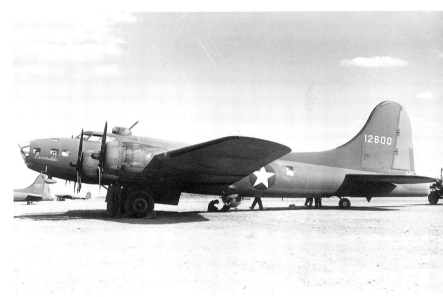

B-17E 41-2435 of the 40th BS, 19th BG, pictured over the Owen Stanleys, was shot down off Buna on 12 August 1942. Note the power-operated Bendix belly gun turret, which was installed in the first 112 Es on the production line and was fired by a gunner lying prone and facing aft, sighting the guns through a periscope arrangement of angled mirrors.

B-17E 41-2600 *Esmerelda* with the much improved ball turret, designed by Sperry, which finally replaced the cumbersome Bendix installation.

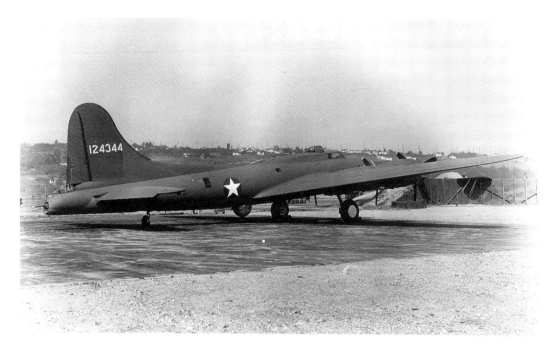

B-17F-1-BO 41-24344 from the first block of F models. The BVD pool was created when Boeing agreed to let Lockheed-Vega and Douglas Aircraft build the B-17F under licence. The first B-17F was delivered to the AAF on 30 May 1942. 41-24344 was assigned to the 326th BS, 92nd BG, at Bovingdon in 1942, and joined the 414th BS, 97th BG, at Polebrook in August. It was lost on the group's last mission from England on 21 October 1942, along with Capt. John M. Bennett's crew.

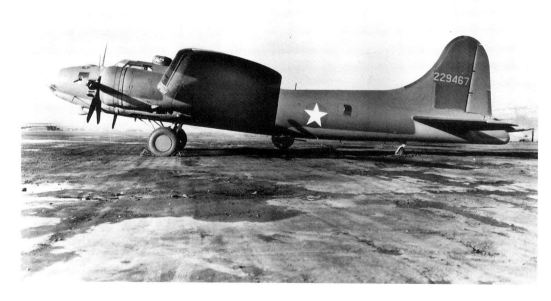

B-17F-55-BO 42-29467 pictured on 18 December 1942. Named *Flak Dodger*, this aircraft flew in the MTO, initially with the 348th BS, 99th BG. The 'F' looked similar to the B-17E, save for a frameless Plexiglas nose, but no fewer than 400 changes and modifications were made, most of them being carried out on the production line.

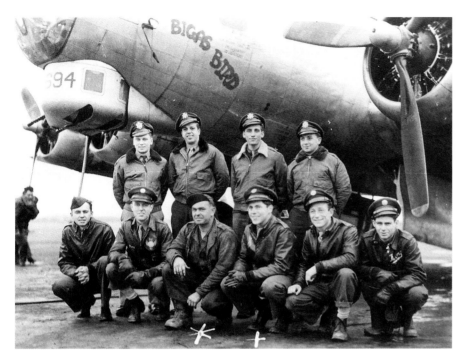

In theatre the olive drab, and later natural metal, factory finish B-17s were nearly always applied with 'nose art' (usually the naked female form) and the practice became synonymous with 8th and 15th Air Force B-17 combat crews. The Fortress earned many sobriquets, namely, 'queen of the skies' and, universally, 'the big ass bird'.

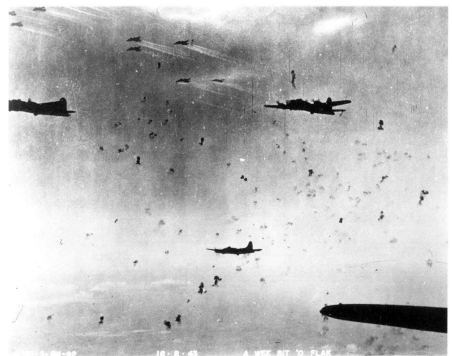

'Flak thick enough to walk on' went the saying, and is evident here in August 1943. At Schweinfurt and Regensburg on 17 August 1943, the 8th Air Force lost sixty B-17s shot down and twenty-seven so badly damaged that they never flew again. Another sixty, which continued to North African bases after the bombing, had to be left behind for repair. The second big Schweinfurt raid, 14 October 1943, cost the 8th another sixty B-17s, plus 138 damaged.

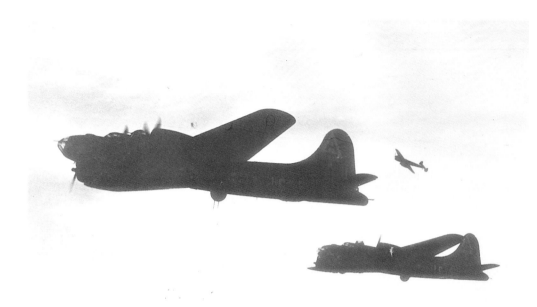

B-17F-70-BO 42-29815 LG-P, *Miami Clipper* (left), and B-17F-65-BO 42-29656 *Terrible Ten*, LG-S, in the 322nd BS, 91st BG, 8th Air Force, under attack by a Bf 110 on 22 January 1944. On 20 February 42-29656, which originally had been assigned to the 358th BS, 303rd BG, and called *Skunkface*, failed to return with 2/Lt Ernest B. Kidd's crew. Two men were killed and eight were captured. *Miami Clipper*, which had first been assigned to the 367th BS, 306th BG, was scrapped at Walnut Ridge, Arkansas, in January 1946.

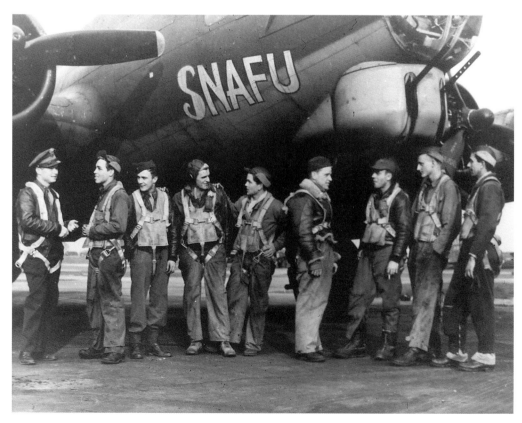

'Situation Normal, All Fouled Up' – SNAFU – although the acronym was known differently in some circles! This particular *SNAFU* is B-17G-15-BO 42-31393 in the 388th BG, 8th AF, which, renamed *Snaky*, failed to return with 2/Lt Donald E. Walker's crew on 29 April 1944.

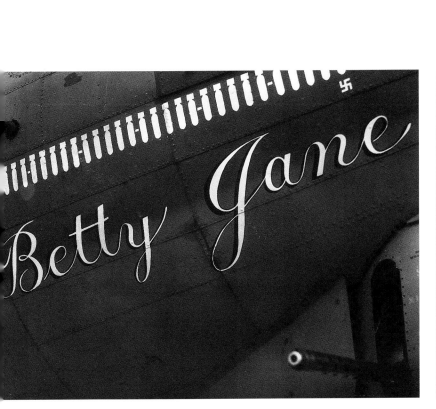

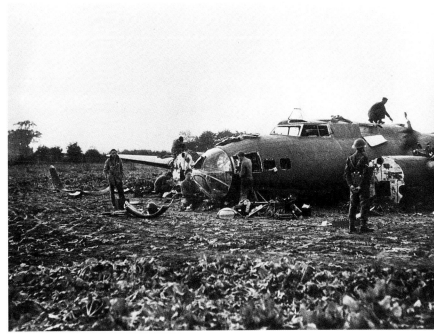

B-17G-35-BO 42-32027 *Betty Jane* in the 427th BS, 303rd BG, failed to return with 2/Lt C.W. Heleen's crew on 13 September 1944. Eight of the crew were captured.

'Any landing you can walk away from is a good landing.' This B-17 made it back to England – just.

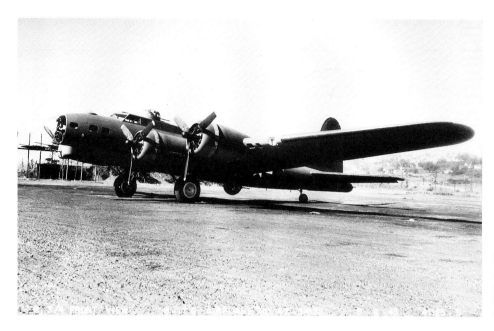

B-17G-1-BO 42-31032 (which was assigned to the 422nd Night Leaflet Squadron, 305th BG, on 25 November 1943) from the first production block. During September 1943, the B-17G (Model 299-O), which first flew on 21 May, appeared in Europe. Its most significant feature was a 'chin turret', fitted for forward defence.

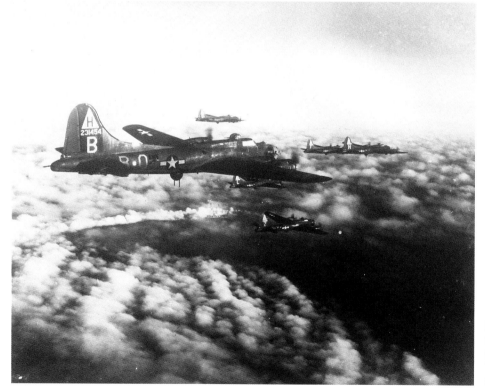

B-17G-20-BO 42-31454 BO-B *St Anthony* in the 368th BS, 306th BG, with B-17G-1-BO 42-31065 GY-Z in the 367th BS, and four other B-17s, in formation. *St Anthony* joined the 100th BG at Thorpe Abbotts in April 1945 and then the ATC on 24 May, being scrapped on 31 January 1946.

B-17G-45-BO 42-97234 LG-M *Bomber Dear* in the 322nd BS, 91st BG, went missing in action with Lt Donald R. Sparkman's crew on 2 November 1944.

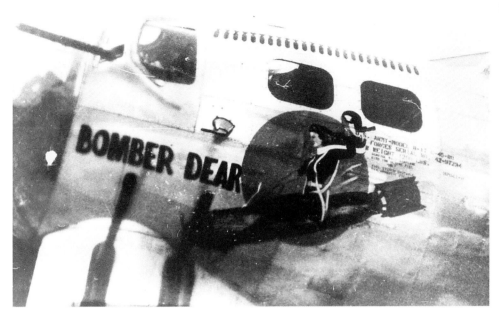

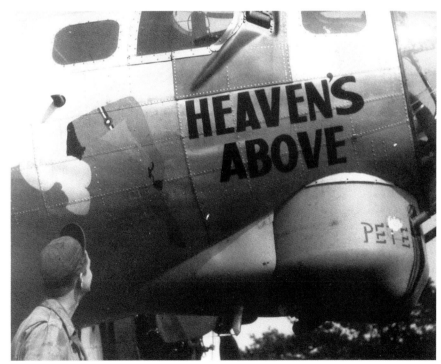

B-17G-45-BO 42-97328 *Heaven's Above* in the 561st BS, 388th BG, 3rd Bomb Division, 8th AF, at Knettishall, Suffolk. The electrically driven Bendix Model 'D' chin turret is enclosed in a movable aluminium alloy housing containing two .50 calibre M-2 machine guns.

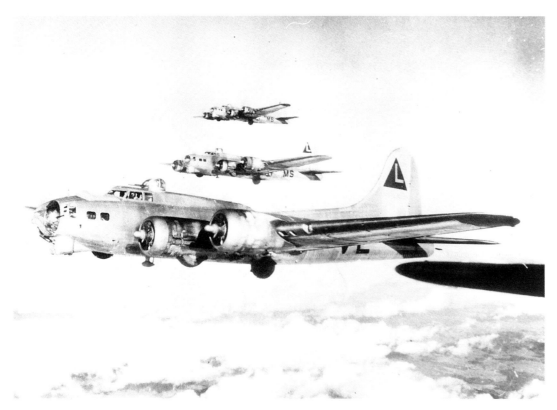

B-17G-70-BO 43-37675, VE-N, originally called *Trudie's Terror*, in the 532nd BS, 381st BG, in formation with two 535th BS B-17Gs. On 1 March 1945 43-37675, now called *Patches 'N' Prayers*, force-landed in France, was repaired and saw out the rest of the war, being scrapped at Kingman, Arizona, in December 1945.

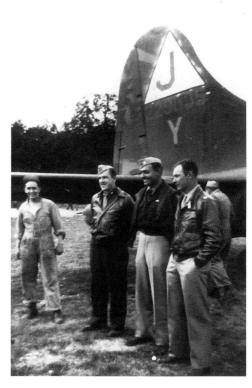

Hollywood movie star Clark Gable, who flew a few missions with the 8th AF, is pictured at the fighter station at Bodney, Norfolk, in 1943, in front of B-17G-75-BO 42-29835 *Pistol Ball* in the 511th BS, 351st BG, after flying in from Polebrook where the actor was making a gunnery training film for the USAF.

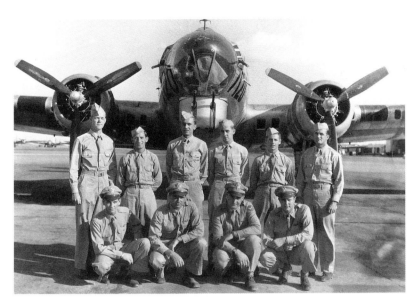

Young men came from every state in America to man the B-17s. This is Robert L. Miller's crew, pictured during training in the US before they joined the 493rd BG at Debach, Suffolk, and flew their personally named B-17G, *Son of a Blitz*.

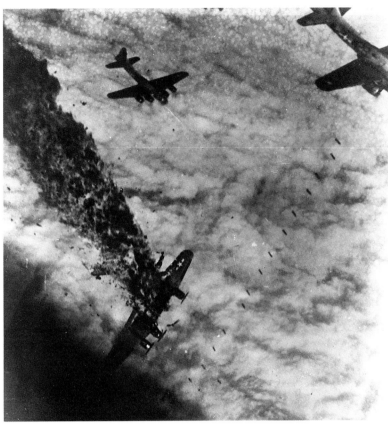

B-17G-75-BO 43-37883 *Blue Streak* in the 834th BS, 486th BG, flown by 2/Lt David Paris, hurtles down after taking a direct flak hit in the left main fuel tank over Merseburg on 2 November 1944. All nine crew were killed in action.

B-17F-100-BO 42-30359 QJ-D in the 339th BS, 96th BG, pictured in North Africa after the Regensburg shuttle bombing mission, 17 August 1943. This aircraft was lost with 2/Lt Linwood D. Langley's crew on 29 November 1943.

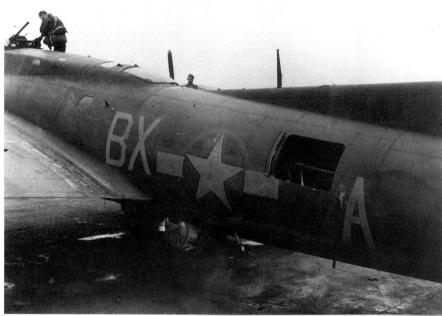

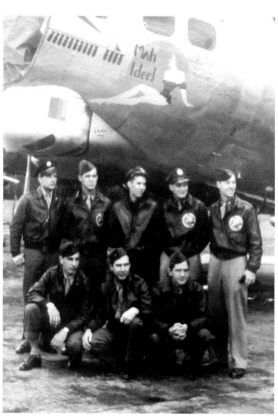

Left: B-17F-100-BO 42-30366 BX-A, *Fertile Myrtle III*, in the 338th BS, 96th BG at Snetterton Heath. It crashed at Silver Fox Farm, Taverham, Norwich, on 16 December 1943.

B-17G 43-37993 *Mah Ideel*, which served in the 401st and 324th BSs, 91st BG, at Bassingbourn before returning to the USA to be scrapped at Kingman, Arizona, in December 1945. Bert Stiles, author of *Serenade to the Big Bird*, is standing at the centre.

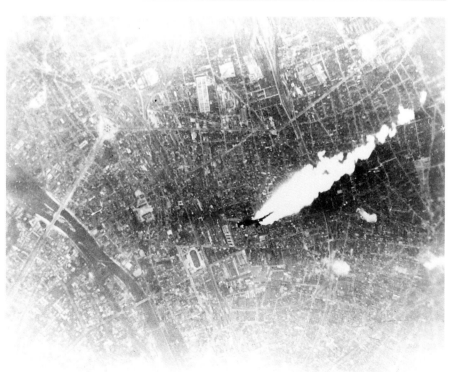

B-17F-110-BO 42-30607 *Pat Hand* of the 337th BS, 96th BG, 8th AF, flown by 2/Lt Kenneth E. Murphy, takes a flak hit over Paris during a raid on the air park at Romilly-sur-Seine on 15 September 1943. One man survived and nine crew died.

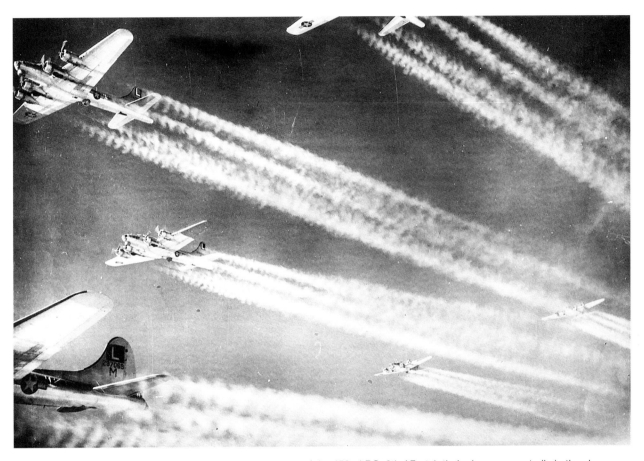

'Where Angels Fear To Tread'. High in the stratosphere B-17s of the 452nd BG, 8th AF, etch their giveaway contrails in the sky.
B-17G-40-BO 42-97069/M *Mon Tete Rouge II* (bottom left) failed to return on 4 December 1944 with 2/Lt Lawrence Downy Jnr's crew.

In Italy, B-17s equipped six bomb groups in the 5th Bomb Wing. B-17G-55-DL 44-6606 of the 2nd BG piloted by Lt Notheis, landed at Miskolc airfield, Hungary, on 21 January 1945 after being damaged during a raid on Vienna. Rumanian ground crews fixed an Hs 129 main wheel to the Fortress to act as a tail wheel to enable the B-17 to take off again!

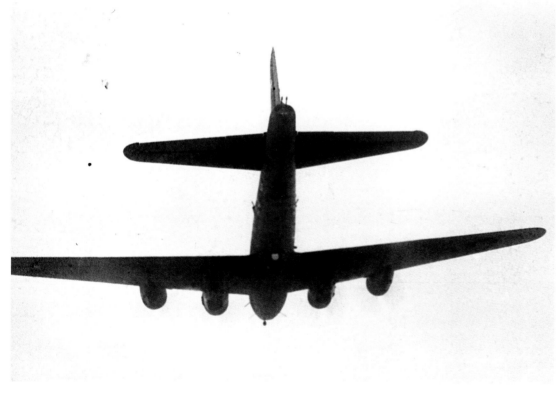

German fighter pilot's eye view of a B-17. Despite their formidable armament, once a Fort had fallen out of formation, they were usually easy prey for Focke-Wulf 190s and Bf 109s.

The RAF operated late model B-17s in Coastal Command and as RCM aircraft in 100 Group (pictured) for 'spoofing' and radar-jamming operations.

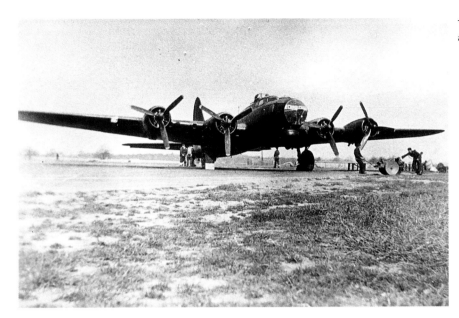

Fortress II (B-17F-40-BO 42-52349) (pictured on a test flight in the US in 1942) arrived in the UK in December 1942 and, coded FA707, served with 206 and 220 Squadrons of RAF Coastal Command, being lost in a crash in the Azores on 26 July 1944.

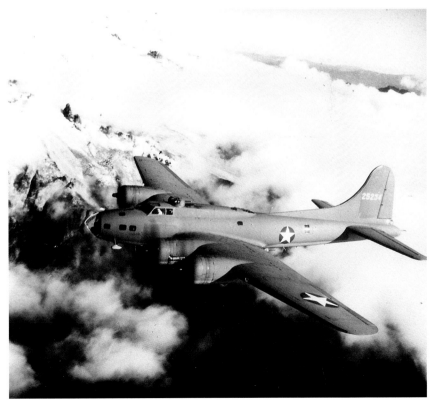

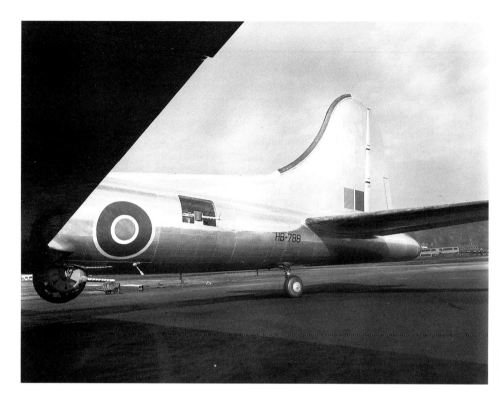

Fortress III HB788 (B-17G-50-BO 42-102439) joined No. 214 Squadron, 100 Group RAF at Oulton, Norfolk, where it was coded BU-B, and was lost on 7 November 1944.

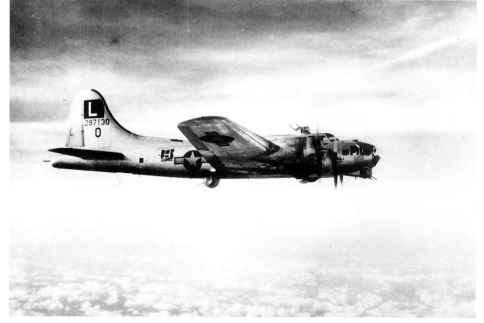

B-17G-40-BO 42-97130 in the 731st BS, 452nd BG, 8th AF.

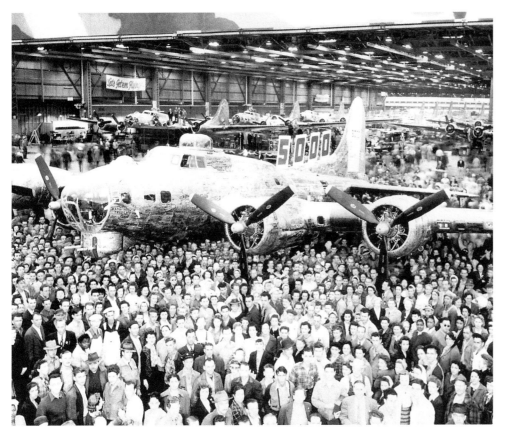

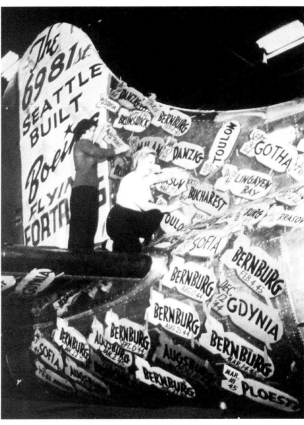

B-17G-70-BO 43-37716 *Five Grand*, the 5,000th B-17 built at Boeing Seattle since Pearl Harbor, was covered with the signatures of Boeing employees. *Five Grand* flew seventy missions in the 96th BG at Snetterton Heath, Norfolk, and was scrapped, like thousands of others, at Kingman, Arizona, in 1945.

Boeing ceased Fortress production on 13 April 1945 to concentrate on the B-29 Superfortress. 43-39508, from Block B-17G-110-BO, was the 6,981st Fortress built by Boeing and is decorated with removable paper bomb cut-outs commemorating enemy targets bombed by B-17s.

Clockwise from right: B-17E 41-9210 was put on display at the University of Minnesota in November 1945 for seven years. After operating in Canada and Florida, the B-17 was purchased by Compañía Boliviana de Aviación of La Paz in July 1964 and registered CP-753. On 3 January 1974, operating now with Frigorificos Reyes, the port undercarriage collapsed while taxiing. In 1992 the B-17 (now registered N8WJ) was acquired by Scott D. Smith of Colorado Springs.

B-17G-90-BO 43-38635 was used after the war by the Atomic Energy Commission. In 1959 it was registered N3702G before being converted to a fire-tanker (No. 61) in 1960. In 1979 it was restored, named *Virgin's Delight*, and put on display at the Castle Air Museum, Castle Air Force Base (AFB), Merced, California. The original *Virgin's Delight* was flown by Col. (later Brig. Gen.) Frederick Castle (after whom the base is named), who was killed in action on 24 December 1944. He was posthumously awarded the Medal of Honor.

Three experimental Model 400 single-seat fighter-torpedo bombers, powered by a 2,500hp P&W R-4360 driving a six-blade contra-rotating airscrew, were built for the US Navy as the XF8B-1. The first aircraft (pictured) flew on 27 November 1944.

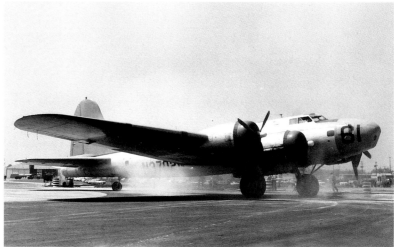

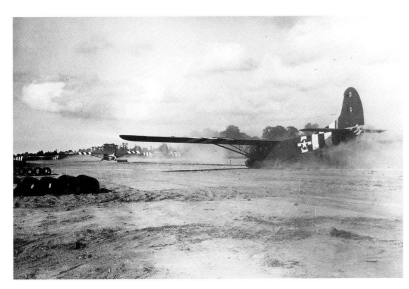

Cessna Aircraft of Wichita, Kansas, was selected to build 750 Waco CG-4A troop carrying gliders but the company subcontracted the entire order to the Wichita Division of Boeing, who literally built them in the aisles of the new Plant 2 while tooling up for Superfortress production.

B-29s on the ramps outside Seattle Plant 2 late in the war. Early in 1942 the plant was concealed with a camouflage hill, complete with city housing, streets, and cars.

Finish the Fight – with War Bonds

Skyscraper

Stand where you can look at one single part of the Boeing B-29 Superfortress . . . the huge tail, tall as a three-story house. High above you are the deadly hooded guns and the tail gunner's compartment of bullet-proof glass. Horizontal tail surfaces reach out on either side, wider than the wingspread of what was once considered a good-sized airplane.

Size alone is not the remarkable thing about the B-29, however; there have been big planes before.

But there has never been a plane that would carry as heavy a bomb load so far, so fast, so high. Nor has such an airplane ever before been successfully designed,

tested, and manufactured in quantity . . . in time to get into action *during* a period of war!

Boeing measured up to this huge task which included engineering the B-29 so it combined high-performance characteristics with great load carrying ability; manufacturing it on a scale never before thought possible for so large and potent an aerial weapon.

This latter meant the blazing of new trails in tooling and production planning. It meant the originating of new facilities and processes. It meant not only the making of the manufacturing plan and putting it into operation in Boeing's own plants, but assisting the

other aircraft manufacturers, which were chosen by the Army to help Boeing build the B-29's. And it meant doing all these things while the Superfortress itself was still in the development stage!

Today the Boeing Superfortresses are taking their place alongside the famous Flying Fortresses as a great fighting team. They represent Boeing's effort to give American Air Force crews the best possible weapons for performing their vital and hazardous missions.

Tomorrow Boeing research, design, engineering and manufacture will be applied to peacetime airplanes—your assurance that any product "Built by Boeing" is bound to be good.

DESIGNERS OF THE B-29 SUPERFORTRESS • THE FLYING FORTRESS • THE NEW STRATOCRUISER • BOEING
THE KAYDET TRAINER • THE STRATOLINER • PAN AMERICAN CLIPPERS

Superfortress advertisement.

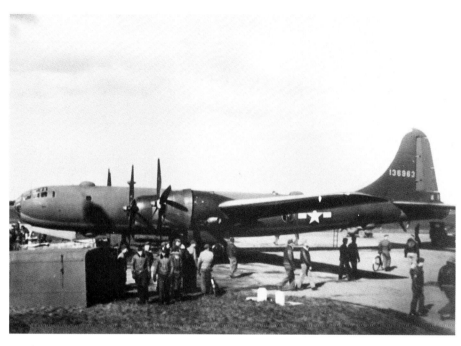

Superfortresses never served operationally in England in the Second World War, although YB-29 41-36963, one of a batch of fourteen Wichita-built service test aircraft, seen here at Horsham St Faith, Norwich, did a tour of USAAF bases in East Anglia to make the Germans believe that perhaps they just might be used.

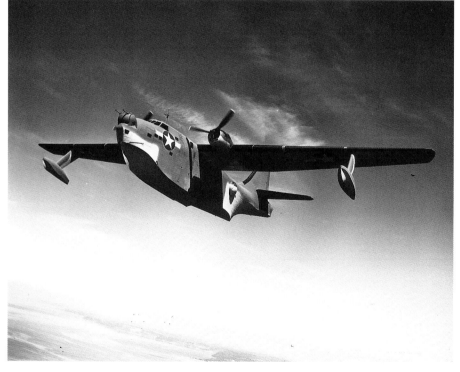

The XPBB-1 (Model 344) using a wing similar to the B-29 was built to a US Navy requirement for a very long range flying boat patrol-bomber. In 1942 the need for this type of seaplane diminished so the Renton factory, built for the production of the PBB-1 Sea Ranger for the US Navy, was turned over to the army for production of the B-29 Superfortress.

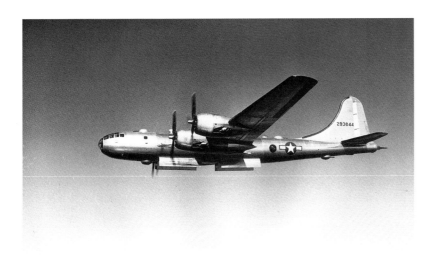

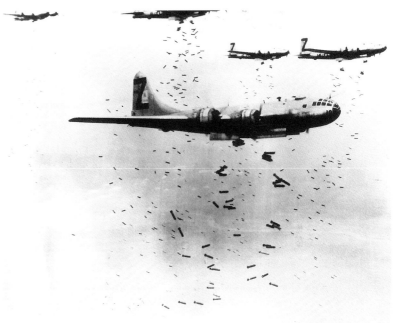

B-29A-BN 42-93844, with both sets of bomb bay doors open. Renton-built aircraft differed only in having four guns instead of two in the front turret.

B-29s in the 500th VHBG, 73rd Bomb Wing, dropping bombs on Japan.

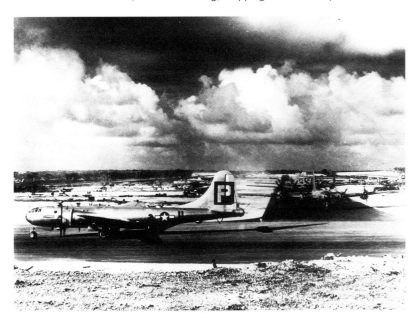

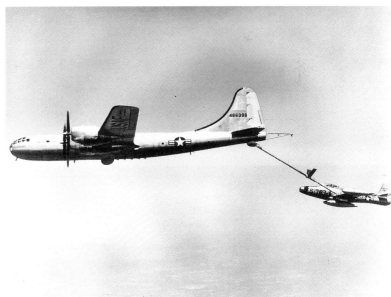

B-29 *Censored* of the 39th VHBG taxies out at North Field, Guam. The 39th flew their first mission to Maug, in the northern Marianas, early in April 1945.

YKB-29J-MO (RB-29J) 44-86398, one of 116 B-29s converted to KB-29P tanker aircraft at Renton in 1950–51, refuelling a Republic F-84G Thunderjet by means of the 'Flying Boom' developed by Boeing to replace the hose refuelling system.

Clockwise from right: A US Navy P2B-1S, one of four B-29-BWs obtained in 1947, which was used to air-launch the rocket-powered Douglas D-558-II research aircraft.

In March 1948 two B-29s demonstrated the feasibility of air-to-air refuelling using trailing hoses and grappling hooks to make contact. A total of ninety-two B-29s were re-designated KB-29Ms, and six were used to refuel the B-50A *Lucky Lady* II, which made the first ever non-stop round-the-world flight in February 1949. During the time of the Korean War in 1950-53, B-29s equipped four wings and one reconnaissance squadron in SAC, and the 19th BG in the 20th AF.

Britain obtained eighty-eight ex-mothballed B-29s and B-29As, calling them Washington B.Is, on loan from the US, between 1950 and 1955, to supplement RAF Bomber Command's ageing Lincolns, pending delivery of Canberra and V-bomber jet aircraft. Here, B-29A-BN 44-61599 is pictured on arrival at RAF Marham, Norfolk, in March 1950 where No. 149 Squadron became the first to be equipped with the Washington B.I.

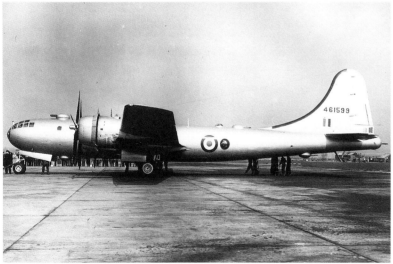

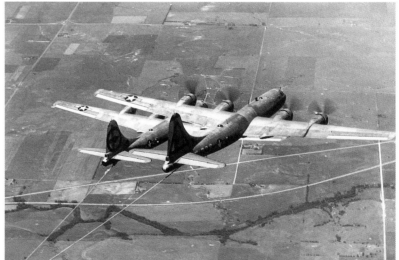

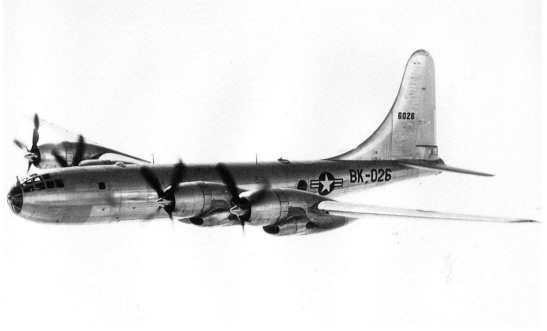

Senior RAF officers salute the arrival of four Washingtons. In all, Washingtons equipped eight front-line squadrons in Bomber Command, and by 1958 almost all of the 'stop-gap' bombers had been returned to the US.

The Pratt & Whitney Wasp Major-engined B-29D was re-designated the B-50A before service deliveries took place; the first B-50A (46-002) flew on 25 June 1947. The taller fin and rudder, which were among several new features and improvements, are evident in this picture of B-50A 46-026.

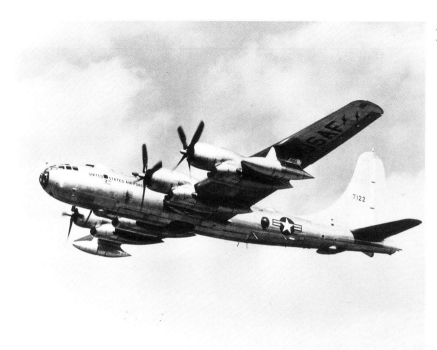

47-122, one of fourteen RB-50B (RB-50E) reconnaissance versions of the B-50A that were modified at Wichita.

Some 112 of the 136 B-50As and B-50Bs that had been converted to KB-50 hose tankers by Hayes Industries were designated KB-50J. Here KB-50J 48-123 refuels three North American F-100A Super Sabres of Tactical Air Command simultaneously.

The P-12/F4B was an American pursuit aircraft that was operated by the USAAC and US Navy. Boeing developed the aircraft as a private venture to replace the F3B and F2B with the US Navy; the first flight of the P-12 took place on 25 June 1928. The new aircraft was smaller, lighter and more agile than the ones it replaced but still used the Wasp engine of the F3B. This resulted in a higher top speed and overall better performance. As result of navy evaluation, twenty-seven were ordered as the F4B-1, later evaluation by the USAAC resulted in orders with the designation P-12. Boeing supplied the USAAC with 366 P-12s between 1929 and 1932. Production of all variants totalled 586. Pictured is a P-12E at the National Museum of the United States Air Force in markings of 6th Pursuit Squadron, 18th Pursuit Group at Wheeler Field, Hawaii.

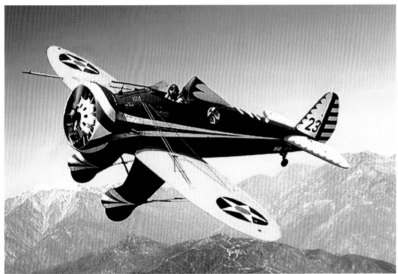

The P-26 Peashooter was the first American all-metal production fighter aircraft and the first pursuit monoplane used by the USAAC. The prototype first flew in 1932 and the type was still in use with the USAAC as late as 1941 in the Philippines. There are only two surviving Peashooters, but there are three reproductions on show with two more under construction.

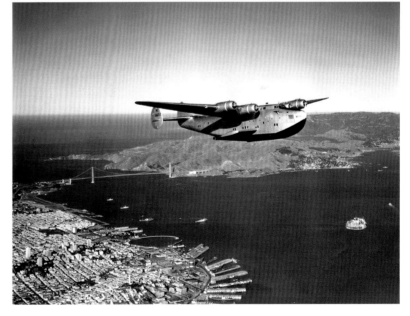

The 314 Clipper (Pan Am Clipper NC18602 No.18 is featured passing the Golden Gate Bridge in San Francisco) was a long-range flying boat produced between 1938 and 1941. One of the largest aircraft of the time, it used the massive wing of the earlier XB-15 bomber prototype to achieve the range necessary for flights across the Atlantic and Pacific Oceans. Twelve Clippers were built; nine were brought into service for Pan Am and later transferred to the US military. The remaining three were sold to British Overseas Airways Corporation (BOAC) by Pan Am and delivered in early 1941.

Clockwise from right: The Stearman Model 75 biplane was used as a military trainer aircraft, of which at least 10,626 were built in the United States during the 1930s and 1940s. Stearman Aircraft became a subsidiary of Boeing in 1934. (Author)

Developed in the 1930s for the United States Army Air Corps, no fewer than 12,731 B-17 Flying Fortresses (B-17B pictured) were built.

The first B-17B 38-211 MD105 (assigned to the air corps' material division at Wright Field on 2 August 1939 – hence 'MD' unit designator) in flight. This Fortress first flew at Seattle on 27 June 1939 and was delivered to Wright Field for armament testing on 2 August. It crash landed 8 miles east-north-east of Hendricks Field on 22 October 1942 and was written off on 2 December 1943. The offset aircraft commander's blister behind the cockpit was moved to the centreline on the B-17D.

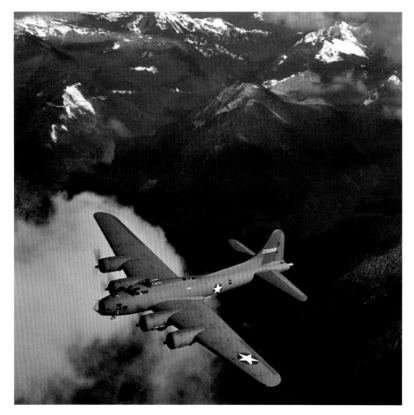

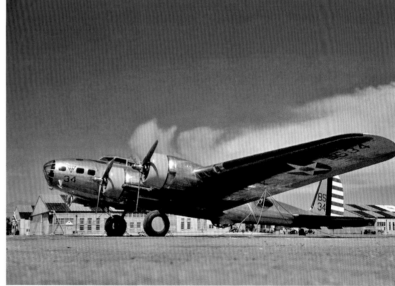

Clockwise from right: As of May 2015 ten B-17s remain airworthy. None, including B-17Gs *Liberty Belle* (constructed from two damaged aircraft (non-combat 44-85734 and the rear part of 44-85813, which was destroyed in a fire in 2011 after an emergency landing) and 44-83546/N3703G painted to represent *Memphis Belle* in formation in New York State, are combat veterans. Additionally, a few dozen more are in storage or on static display. The oldest is a D-series combat veteran with service in the Pacific and the Caribbean. (Author)

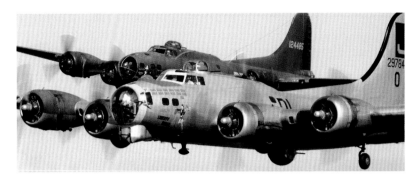

The L-15 Scout or YL-15 was a small, short take-off and landing (STOL) aircraft powered by a 125hp Lycoming engine built in very small numbers after the Second World War as Boeing's production of combat aircraft declined. Boeing decided against marketing the L-15 as a general aviation aircraft and the twelve that were produced went to the US Army for testing then were transferred to the US Fish and Wildlife Service in Alaska for various duties.

Some 3,970 B-29 Superfortresses were built and all served in the China-Burma-India and Pacific theatres in the Second World War. One of the B-29's final roles was carrying out the atomic bomb attacks on Hiroshima and Nagasaki. Today, only one B-29 (*FIFI* of the Commemorative Air Force, pictured near Elmira/Corning) survives in flying condition although, as of 2015, another B-29 was being restored for flight. (Author)

American post-war military assistance programmes loaned the RAF enough Superfortresses to equip several RAF squadrons (pictured is Washington B.I. WF555 (ex-USAF 44-62254 B-29A-70-BN) of 57 Squadron. This aircraft crash landed on a disused airfield near Amiens, France, on 29 September 1951 after one propeller fell off and two engines failed). RAF Bomber Command flew the B-29 as the Washington until phasing out the type in 1954.

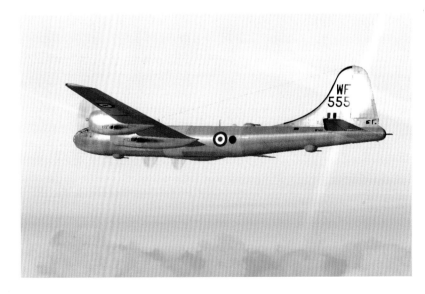

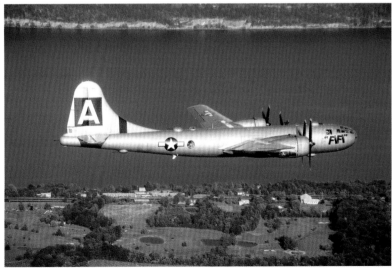

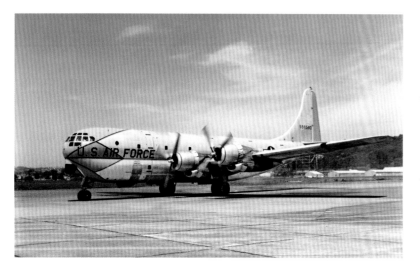

Left: The 377 Stratocruiser (USAF Stratocruiser 55-9593 pictured) was a large long-range airliner developed from the C-97 Stratofreighter military transport, a derivative of the B-29 Superfortress. The Stratocruiser's first flight was on 8 July 1947 and fifty-six were built 1947–49. Pan American World Airways was the largest Stratocruiser operator, with twenty-nine Model 377s. Ten PM-26s were modified to Super Stratocruisers by adding an additional 450 gallons of fuel to permit non-stop flights between New York and London and Paris, and 55 to 100-plus people could be accommodated according to the length of the route and the type of service. A complete galley for hot meal service was located near the tail and men's and women's washrooms separated the forward compartments from the main passenger cabin, where a spiral stairway led to a deck lounge on the lower deck behind the wing. When fitted out as a sleeper aircraft, the 377 was equipped with twenty-eight upper- and lower-berth units plus five seats. (Boeing)

Right: The B-47 Stratojet was a long-range, six-engine, turbojet-powered strategic bomber designed to fly at high subsonic speed and at high altitude to avoid enemy interceptor aircraft. Six Allison J35-2 turbojet engines slung in pods beneath the swept-back wings powered the prototype Stratojet although uprated J47-GE-3s were soon substituted; the B-47 also carried mountings for eighteen solid-fuel booster rockets in the aft fuselage to shorten the take-off roll. B-47s began entering the inventory in 1952. A total of 2,039 B-47s were built in a serial production that lasted until 1956.

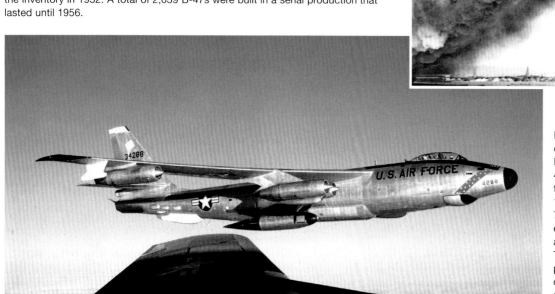

RB-47H Stratojet 34288 in flight. Boeing development of a jet bomber began in 1943 and the Model 450 was approved in April 1946. Stratojet 46-065, rolled out on 12 September 1947, was the first of the two XB-47 prototypes to fly, on 17 December 1947. The first steps towards the 747 began with the B-47 Stratojet with its podded engines and new thin wing, swept back at an angle of 35 degrees at the quarter-chord point. The second XB-47 flew in July 1948 with the more powerful General Electric J47 powerplant of 5,200lb of thrust in place of the earlier J35s of only 3,750lb of thrust. (Boeing)

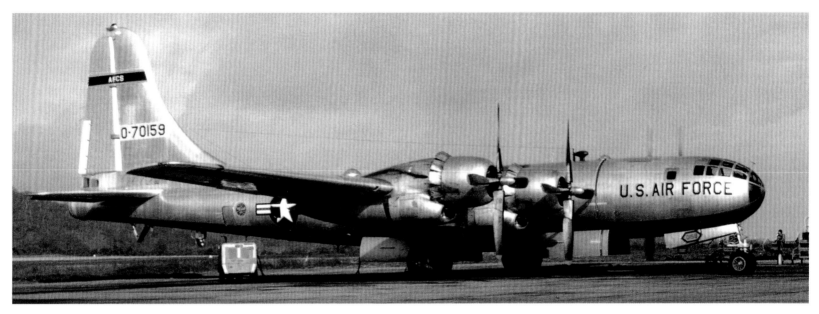

The B-50 Superfortress strategic bomber (B-50B 47-0159 pictured) was a post-Second World War revision of the B-29 Superfortress, powered by more powerful Pratt & Whitney R-4360 radial engines, with a stronger structure, a taller fin, and other improvements. The last piston-engined bomber designed by Boeing for the USAF, the B-50 remained in USAF service for almost twenty years. After its primary service with SAC ended, B-50 airframes were modified into aerial tankers for Tactical Air Command (KB-50) and as weather reconnaissance aircraft (WB-50) for the Air Weather Service. Both the tanker and hurricane hunter versions were retired in March 1965 due to metal fatigue and corrosion problems.

B-52Ds at Carswell AFB, Texas. This strategic bomber has been operated by the United States Air Force since the 1950s and is still in service today. Boeing was awarded a production contract for thirteen B-52As and seventeen detachable reconnaissance pods on 14 February 1951.

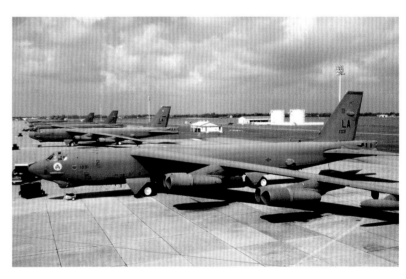

B-52Hs of the 11th Bomb Squadron, 2nd Bomb Wing on the ramp at Barksdale AFB in October 2003. (Author)

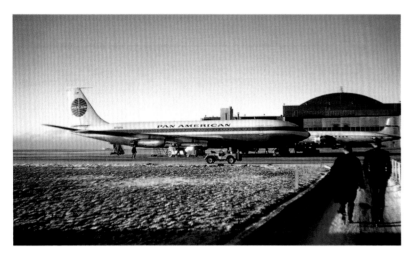

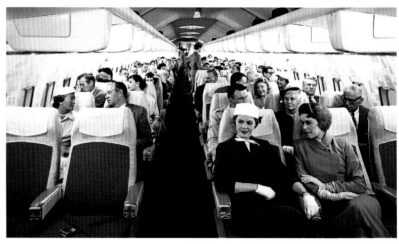

Pan Am 707-321 N730PA *Bald Eagle* which first flew on 15 April 1960 and was delivered to the airline on 28 April that same year. Developed as Boeing's first jet airliner, the swept-wing design with podded engines was built by Boeing Commercial Airplanes during 1958–79. Although it was not the first jetliner in service, the 707 was the first to be commercially successful. Some 1,011 airliners including the smaller 720 series were produced and delivered and more than 800 military versions were also produced. There were ten 707s still in commercial service in July 2013.

Interior of the 707's cabin.

President John F. Kennedy exits Air Force One VC-137A 58-6972 on arrival at Mexico City on 29 June 1962. The VC-137A was a VIP transport aircraft (derived from the 707 jet airliner used by the United States Air Force. Other nations also bought both new and used 707s for military service, primarily as VIP or tanker transports. In addition, the 707 served as the basis for several specialised versions, such as the E-3 Sentry AWACS aircraft. The designation C-18 covers several later variants based on the 707-320B/C series.

The VC-25A (28000 seen here passing Mount Rushmore) is the designation of a USAF passenger transportation aircraft, a military version of the 747 airliner. The two modified 747s are designated VC-25A by the USAF.

VC-25A 28100 landing during a VIP visit. In 2009 the USAF announced the need for a new presidential plane, as the successor to the 747-2G4Bs built in 1990). The new presidential plane is expected to enter into service in 2017 at the latest.

Clockwise from right: The KC-135 Stratotanker is a military aerial refuelling aircraft. Both the KC-135 and the 707 airliner were developed from the 367-80 prototype. The KC-46 Pegasus was declared the winner in the KC-X tanker competition to begin replace the ageing fleet of KC-135 Stratotankers in August 2017.

The Skyfox twin-engined jet trainer aircraft, a highly upgraded development of the Lockheed T-33, was designed as a primary trainer to compete with and replace the Cessna T-37 Tweety Bird. However, faced with a lack of customers, Boeing cancelled the project. The prototype aircraft remains the only Skyfox built.

Eastern Airlines 720-025 N8710E at New York JFK Airport. A four-engine narrow-body short- to medium-range passenger jet airliner developed in the late 1950s from the Boeing 707, the 720 had a shorter fuselage and less range. Although only 154 were built, the 720/720B was still profitable due to the low research and development costs of it being a slightly modified version of the 707-120. It was later replaced by the Boeing 727.

A mid-size narrow-body three-engine jet aircraft built by Boeing Commercial Airplanes from the early 1960s to 1984, the 727 (Pan Am 727-21 N355PA *Clipper Nuremberg* pictured) can carry 149 to 189 passengers and later models can fly up to 2,700 nautical miles non-stop.

Pan Am 737-297 N70724 *Clipper Spreeathen* at Zurich Airport in May 1985.

Frontier Airlines 737s at Denver. 737-201 N207AU, the nearest aircraft, first flew on 9 September 1968. 737-3M8 N303FL first flew in 1996. The third aircraft is 737-201 N212US. Originally envisioned in 1964, the initial 737-100 made its first flight in April 1967 and entered airline service in February 1968 with Lufthansa. Next, the lengthened 737-200 entered service in April 1968. In the 1980s Boeing launched the -300, -400, and -500 models, subsequently referred to as the Boeing 737 Classic series. (Author)

Lufthansa 737-530 D-ABII *Oberhausen* first flew on 22 March 1991. (Author)

KLM 737-306 PH-BTE *Roald Amundsen* at Schiphol Airport, Amsterdam. (Author)

EgyptAir 737-566 *Ramesseum* SU-GBL in May 2005. (Author)

Pan Am 747-121 Clipper *Storm King* passing JAT 727-2H9 YU-AKB and TAP 707-3F5C CS-TBU at Heathrow.

A modified version of the 747 jet airliner the SP 'Special Performance' (Qantas 747-SP-38 VH-EAA *City of Gold Coast Tweed* is pictured in January 1981) was designed for ultra long-range flights.

El Al 747-237B 4X-AXA at Heathrow. The 747-200B was the basic passenger version, with increased fuel capacity and more powerful engines; it entered service in February 1971.

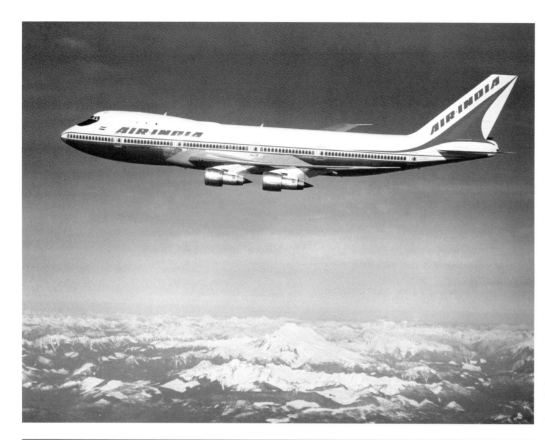

Air India 747-237B VT-EBD *Emperor Ashoka*. This aircraft crashed on Sunday 1 January 1978 1.9 miles west of Bombay-Santacruz Airport in India en route to Dubai with the loss of all twenty-three crew and 213 passengers.

Dragonair Cargo 747-3H6(SF) B-KAC leaving Manchester in August 2003. Swissair placed the first order for the 747-300 on 11 June 1980. The stretched upper deck has two emergency exit doors and is the most visible difference between the -300 and previous models. A total of eighty-one 747-300 series aircraft were delivered: fifty-six for passenger use; twenty-one -300M and four -300SR versions. In 1985, just two years after the -300 entered service, the type was superseded by the announcement of the more advanced 747-400. The last 747-300 was delivered in September 1990 to Sabena. (Gerry Manning)

4

STRATOCRACY

Shades of *Doctor Strangelove*.

Model 367-5-5 YC-97A 45-59590, one of ten service test models of the C-97 Stratofreighter of the Air Transport Command, crossing San Francisco's Golden Gate bridge. The C-97 was designed in 1942 as a heavy cargo transport and bore the same aerodynamic and structural relationship to the B-29 that the Model 307 Stratoliner bore to the B-17. The first YC-97A flew on 28 January 1948 and the first of fifty production C-97As for the Military Air Transport Service flew in June 1949.

The Model 377 Stratocruiser was an airline development of the C-97 and fifty-six were built side-by-side with B-50s on the Seattle production lines between 1947 and 1949. Pan American World Airways was the largest Stratocruiser operator, with twenty-nine, including Model 377-110-26 N1023V, pictured here.

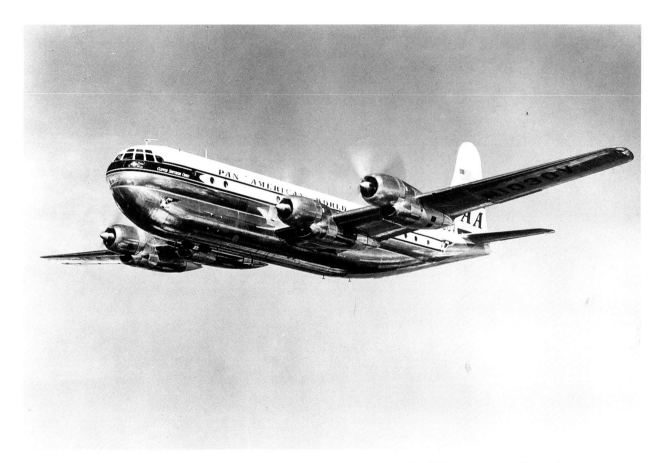

Model 377-10-26 N1030V *Clipper Southern Cross* of Pan American World Airways. Ten PAA -26s were modified to Super Stratocruisers by adding an additional 450 gallons of fuel to permit non-stop flights between New York and London and Paris.

Stratocruisers offered the last word in passenger comfort and between fifty-five and 100 people could be accommodated according to the length of the route and type of service. A complete galley for hot meal service was located near the tail. Men's and women's washrooms separated the forward compartments from the main passenger cabin, where a spiral stairway led to a deck lounge on the lower deck behind the wing. When fitted out as a sleeper aircraft (pictured), the 377 was equipped with twenty-eight upper and lower berth units plus five seats.

Korean war casualties on board a Military Air Transport Service (MATS) MC-97C bound for the US. Fourteen C-97Cs were built.

A stunning night shot of BOAC Stratocruisers at Heathrow. The nearest aircraft is G-ALSA *Cathay*, one of six 377-10-28s bought by the airline. Altogether, BOAC acquired seventeen Stratocruisers (four later operated with SAS), and in 1958 Transocean Airlines of Oakland, California, bought thirteen of these.

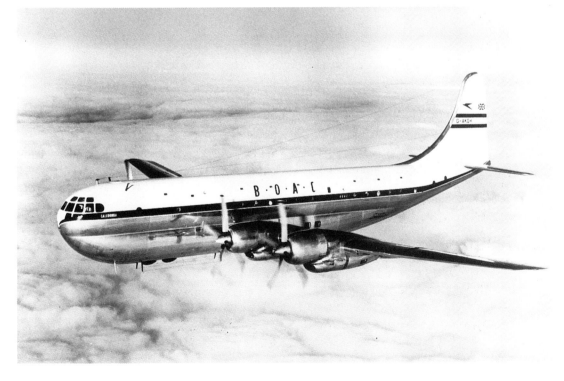

Model 377-10-32 G-AKGH *Caledonia* of BOAC, one of six -32s ordered by the airline, and one of the ten Stratocruisers sold to Transocean Airlines of Oakland, California, in 1958, to make way for newer jet transports.

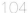

C-97A 49-2591, one of three from a total of fifty built that were converted to KC-97A configuration, seen here refuelling a Boeing B-50D 49-304. Outwardly, the C-97A differed from the YC-97A in the installation of a chin radome housing AN/APS-42 search radar.

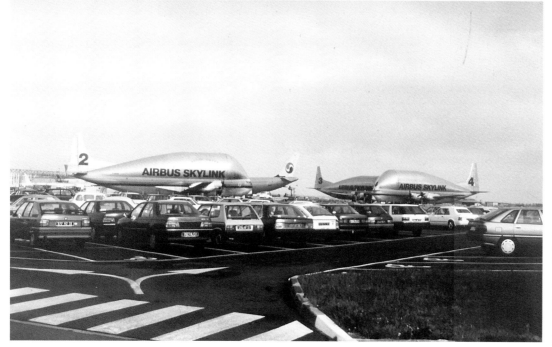

Nine Stratocruisers were converted to 'Guppy' aircraft. N1024V, the second PAA 377-10-26, was converted to a 377-PG (Pregnant Guppy) to transport large spacecraft sections and flew for the first time on 16 September 1962. This was followed by five Super Guppies (377-SG/Model 201), and three Mini Guppies (377-MG/Model 101). Airbus Industrie in Toulouse, France, used four Super Guppies, (pictured in April 1990) for airlifting major Airbus components around Europe.

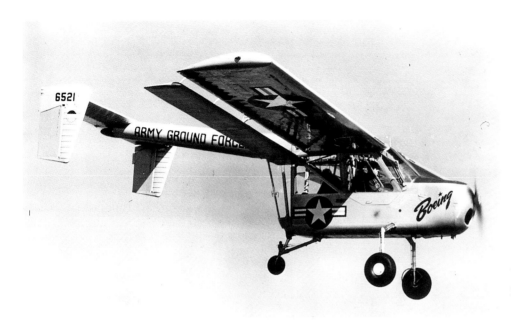

The L-15 Scout (Wichita Model 200/Seattle Model 451) liaison aircraft was designed and built in Wichita. Two XL-15s and ten YL-15s were completed in 1947–48, the first flight being made on 13 July 1947.

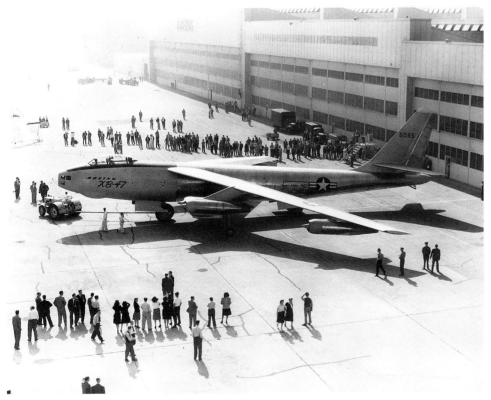

Boeing development of a jet bomber began in 1943 and the Model 450 was approved in April 1946. 46-065, seen here being rolled out on 12 September 1947, was the first of the two XB-47 prototypes to fly from Boeing Field, Seattle, to nearby Moses Lake AFB, on 17 December 1947.

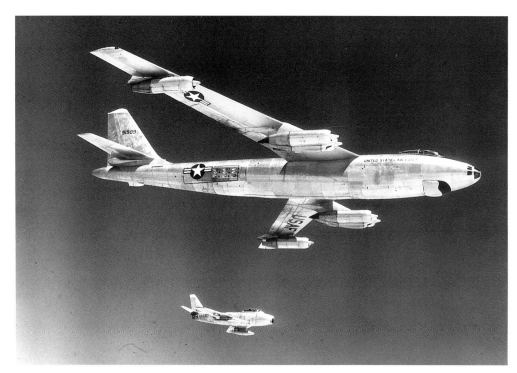

The first B-47A flew on 25 June 1950. 49-1909, the last of ten Wichita-built Model 450-10-9 B-47As, fitted with eighteen external solid-fuel jet-assisted take-off (JATO) rockets, each having a thrust of 1,000lb. Altogether, 2,032 B-47s were built: 1,373 by Boeing, 274 Es by Douglas, and 385 E-LMs by Lockheed.

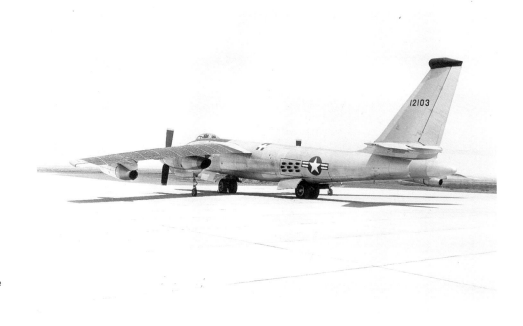

B-47D 51-2103, one of two (the other was 51-2046) that became XB-47Ds when converted to act as test beds for the Wright YT-49-W-1 turboprop engine.

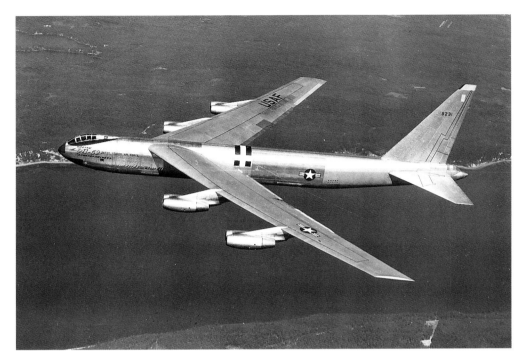

The designation B-52 was originally assigned in 1946 to a straight-wing long-range bomber to be powered by six turboprop engines. By October 1948 the design had undergone a rapid transformation with swept wings and eight Pratt & Whitney J57 turbojets, and the new B-52 Stratofortress was designed and built as Boeing Model 464. Pictured is YB-52 49-231, the second prototype, which first flew on 15 March 1952. The XB-52 (49-230) flew for the first time on 2 October 1952.

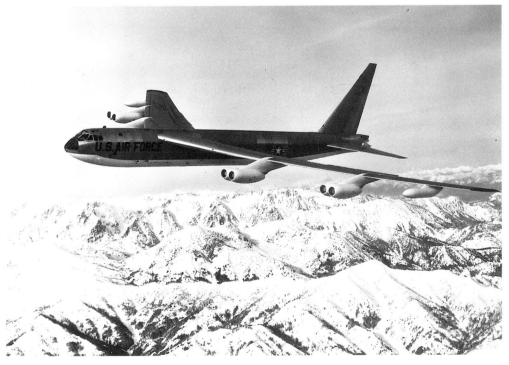

B-52B 53-394 in flight. Thirty B-52Bs and seventeen RB-52Bs were built. The RB-52B carried a photo-reconnaissance or ECM capsule complete with operating personnel that could be installed in the bomb bay for specialised missions. Deliveries to SAC began on 29 June 1955, to the 93rd Heavy Bomb Wing at Castle AFB, California. On 21 May 1956 a B-52B dropped the first airborne hydrogen bomb from 50,000ft above Bikini Atoll.

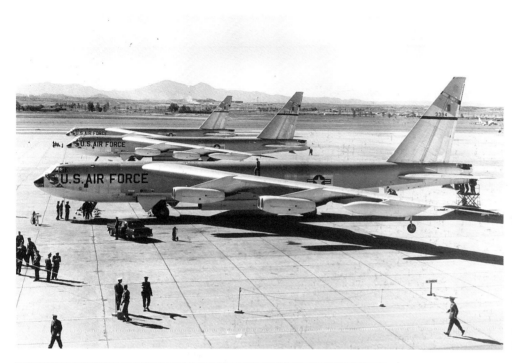

On 18 January 1957 three B-52Bs of the 93rd Heavy Bomb Wing completed a two-day non-stop flight around the world in forty-five hours and nineteen minutes, refuelling three times en route from KC-97s, at an average speed of 520mph for the 24,325 miles.

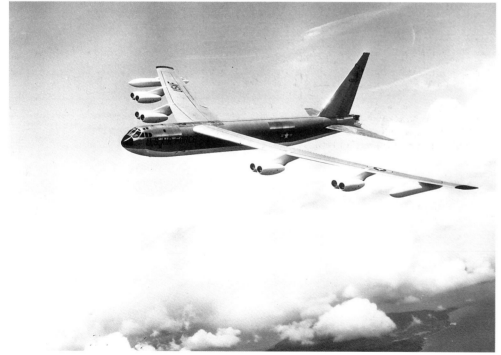

B-52C 54-2669 in flight. A total of thirty-five were built, with 3,000-gallon auxiliary fuel tanks. The first flew on 9 March 1956. This was the first B-52 model to use the white thermal reflecting paint on the under surfaces.

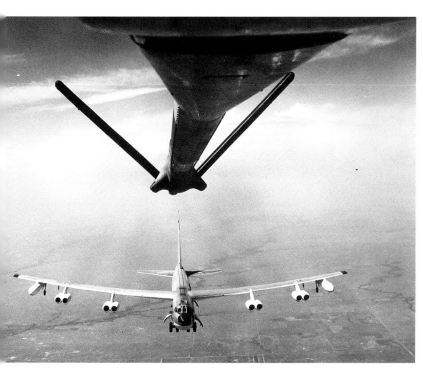

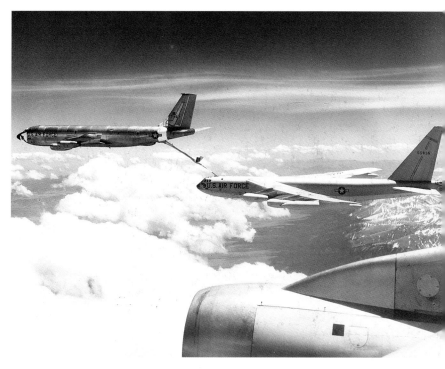

A Wichita-built B-52D, its wheels lowered to slow down to the lower speed of the propeller-driven KC-97, moves in to begin refuelling. A total of sixty-nine Model 464-201-7 (B-52D)s were built at Wichita, and 101 B-52Ds were produced at Seattle.

Tall tails. B-52E 56-635 being refuelled by a KC-135 aerial tanker. Forty-two Model 464-259 B-52Es were built at Seattle and fifty-eight at Wichita. The first B-52E flew on 3 October 1957. A total of ninety-nine B-52Fs were produced at Seattle and Wichita, with the latter plant also building 193 B-52Gs and 102 B-52Hs.

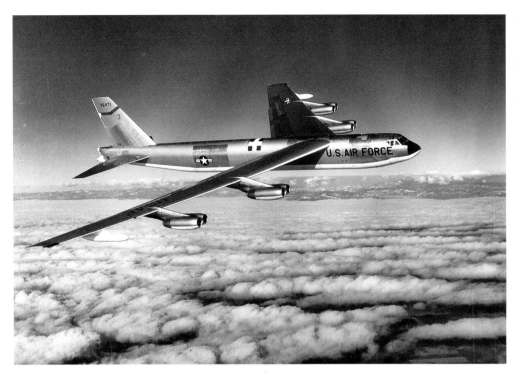

Short-finned B-52G 57-6471 in flight. This model (464-253) first flew on 26 October 1958 and 193 were built at Wichita. The G could carry two AGM-28 (formerly GAM-77) Hound Dog standoff missiles, one on a pylon under each wing between the inboard nacelles and the fuselage. These were phased out in the 1970s, to be replaced by the AGM-69. (The white cross on black square is a photo-theodolite target.)

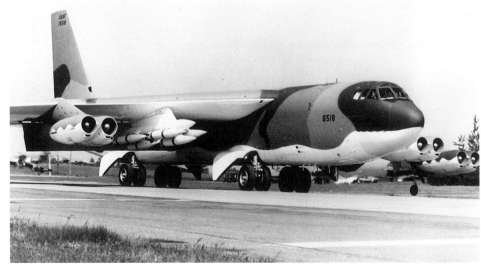

B-52G 57-6518 with AGM-69 subsonic Short Range Attack Missiles (SRAM). Up to twenty could be carried, six on a pylon under each wing and eight on a rotary launcher in the bomb bay, with the capability of hitting several targets hundreds of miles apart on one mission. In 1982–83 the SRAMs were supplemented by a new subsonic Air Launched Cruise Missile (ALCM), twelve of which could be carried on the B-52G and B-52H.

The Vertol Aircraft Corporation at Morton, Pennsylvania, was acquired in 1960 and it became the Boeing Vertol Division, before changing to the Boeing Vertol Co. in 1972. Among its first production designs was the CH-46A Sea Knight (a special version of the twenty-five-passenger Vertol 107-11), which was ordered by the USMC, US Navy (UH-46A) and several overseas air forces.

The first of the UH-61 Chinook helicopters was delivered in 1967 and it has become the primary transport helicopter for the US Army and several air forces overseas. The first flight for the RAF's HC Mk 1 Chinook was on 23 March 1980 at Boeing Vertol's suburban Philadelphia plant.

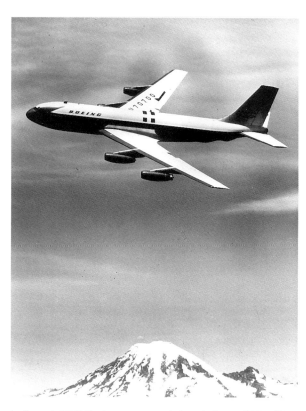

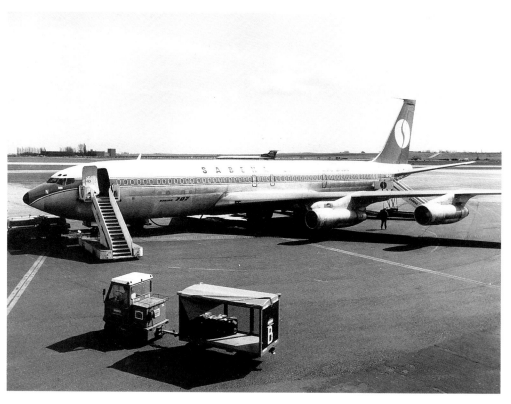

In August 1952 Boeing announced plans to invest $16 million to build an entirely new jet-powered transport, the Model 707. The prototype carried the designation 367-80, which Boeing technicians referred to as the 'Dash Eighty'. The 367-80 707 (N70700) (pictured) flew on 15 July 1954.

Sabena 707-329 OO-SJN, one of ten 707-300s bought by the Belgian airline from Boeing.

Clockwise from right: 707-3B5C HL-7406 of Korean Airlines, the only 707 series model used by this airline.

By 1988 some 120 military 707 variants of various designations, including this Luftwaffe 707-307C (one of four built new and procured by the USAF under the designation C-137 in 1968), had been produced by Boeing.

707-436 G-APFD of BOAC, one of sixteen 707-436 models purchased from Boeing by the British airline.

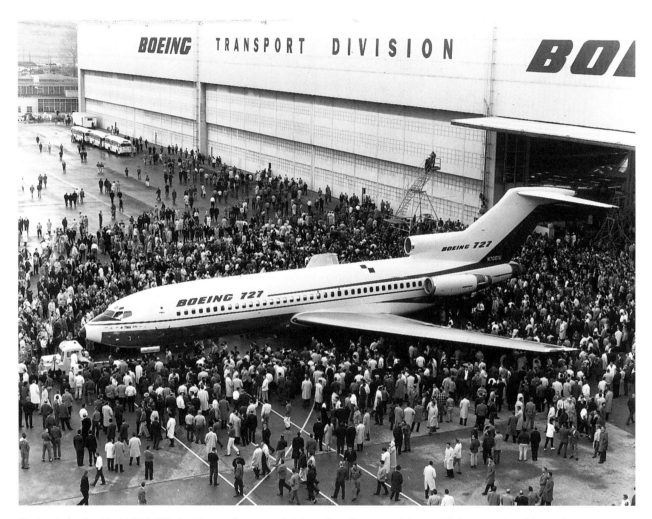

Contracts for the Model 727-100 short-to-medium-range jet, to replace the many piston and turboprop aircraft in service, were signed in December 1960. The first 727, designated 727-22 (N7001U, for United Airlines), was rolled out at Renton on 27 November 1962. Some 408 727-100s were built.

Clockwise from right: N7001U took its first flight (from Renton Field to Paine Field) on 9 February 1963. It was then used for a year as a Boeing test flight aircraft before being delivered to United Airlines on 6 October 1964. After being repainted to its original livery N7001U flew in January 1991 from Boeing Field to Paine Field, where it has been sitting ever since.

Model 727-100 N72700 (No. 1), temporarily registered N1784B, in flight. Model 727 production finally reached 1,831 aircraft through -100, -100C, and -200 aircraft. N72700 first flew on 12 March 1963 and was finally broken up at Paine Field.

No 727s were sold to the US armed forces, but retired airline models were acquired in 1983–84. This 21 Squadron, 15 Wing, Belgian Air Force 727QC (CB-02) based at Melsbroek is pictured taxiing in at Moi International Airport, Mombasa, Kenya, during the international relief effort in February 1993. The last 727 was delivered in September 1984.

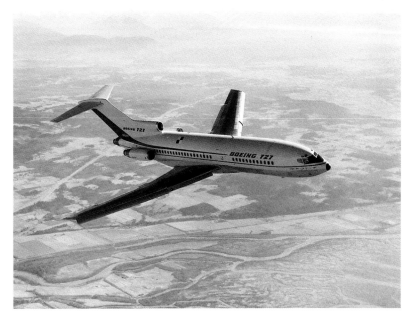

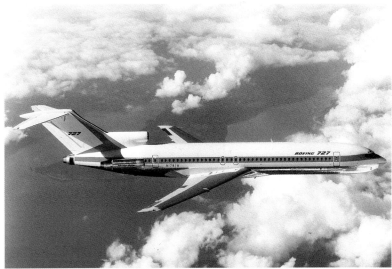

Model 727-2N7(A) (N740RW) belonging to Bahrain being refurbished at Marshalls of Cambridge. The 727-100 had been in service barely a year when Boeing began serious consideration of a stretched, greater capacity development, which resulted in the 727-200, whose development was announced by Boeing in August 1965. The 727-200 was essentially a minimum change development of the 100, the only major alteration being the 20ft fuselage stretch, which increased maximum seating to 189 passengers. The 727-200's stretch consisted of two 10ft plugs, one forward and one rear of the wing. The first flight of the 727-200 occurred on 27 July 1967. N740RW was delivered to Hughes Airwest on 24 March 1980 and to Republic Airlines on 1 October that same year. It joined the Bahrain Royal Flight on 29 July 1981. Winglets were added in 1997.

The prototype Model 737-100 (N73700) first flew on 9 April 1967 and the first of 1,095 737-200s was delivered on 29 December. Lufthansa was the initial customer for the 737-100 with twenty-two ordered (only thirty 737-100s were built).

737-200 G-BICV belonging to Dan-Air. The -200 series was powered by Pratt & Whitney JT8D-9A engines of 15,500lb thrust. The thrust reversers were replaced by a new target type, which added a 45in extension to the rear of the nacelles. A total of 1,097 737-200s were built.

The 737 is the charter airlines' dream machine. Dan-Air operated three 737-3Q8s up until 7 November 1992. Pictured at Gatwick on the occasion of the type's first commercial flight with the airline is G-NNJ11, which was delivered to the airline in February 1988. The -300 entered production in March 1981.

737-300 G-SCUH of Dan-Air in flight. The -300, which was first delivered on 28 November 1984, differed from previous models in having CFM International CFM-56 engines with 'flat-bottomed' nacelles (to permit ground clearance) in place of the JT8Ds of the -100 and -200 series.

Under an $81.7 million contract, nineteen T-43A airborne navigator trainers, based on the basic Model 737 airliner, were produced for the USAF Training Command in 1973–74 to replace part of its fleet of Convair T-29s.

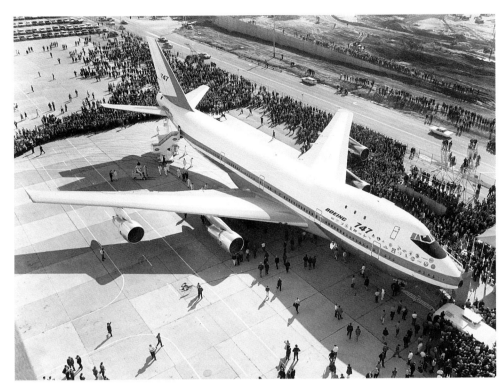

Early in 1966 Pan Am placed a conditional order for twenty-five of the first of Boeing's giant jetliners, the Model 747, capable of carrying 363–490 passengers, or 125 tons of cargo. Full-scale production began in 1967 in a plant measuring 200 million cubic feet on a 780-acre site adjoining Paine Field near Everett, where the first 747-100 (N7470, pictured) was rolled out on 30 September 1968. N7470 flew for the first time on 9 February 1969, and deliveries of 747-121 production models to Pan Am began on 13 December that year.

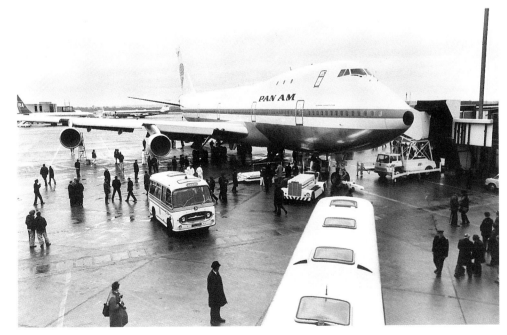

The first 747-100-121, Pan Am's *Clipper Constitution*, arriving at London Heathrow on 12 January 1970, three hours late from New York after one of its Pratt & Whitney JT9D fan-jet engines gave trouble and had to be changed. The aircraft carried more than 300 employees of Pan American, which was to introduce the Jumbo Jet on non-stop passenger flights from New York to London on 21 January 1970.

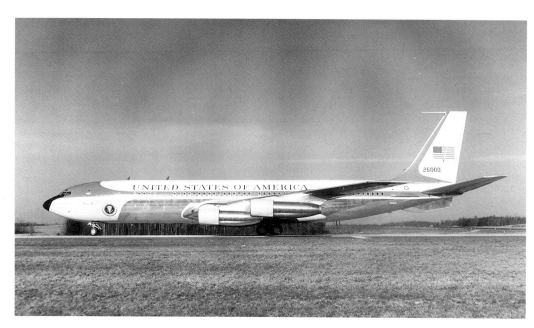

VC-137C 62-6000 was the first of two special 707-353Bs ordered in 1961 for the Office of the President of the United States, and was delivered in October 1962. The second (72-7000) was delivered in August 1972 and was used until replacement by Boeing 747s (C-25A).

President John F. Kennedy is greeted after disembarking from VC-137C 62-6000 at the start of an official visit to RAF Waddington, Lincolnshire, on 29 June 1963.

KC-135A (717-146) 0-10317 taxiing at RAF Gan on 9 March 1972. The Model 367-80 was a logical outgrowth of the basic 707 airliner design and the first twenty-nine KC-135As were given the company designation 717-100A. Note the circumferential stiffeners (aluminium strips) applied to the rear fuselage in front of the dorsal fin, devised to prevent the impingement of turbojet sound waves causing sonic fatigue in the aluminium skin of the rear fuselage.

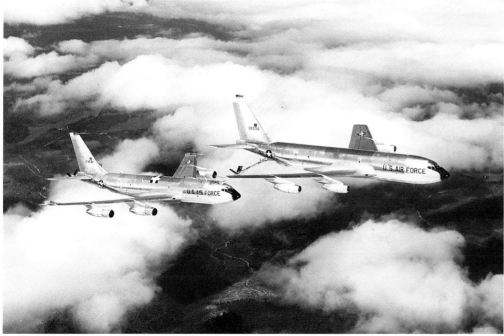

KC-135A 63-8036 refuelling KC-135B 62-3581. The tanker was ordered into limited production in July 1954 and first flew on 31 August 1956. Deliveries to SAC began on 28 June 1957 and when the final delivery was made in January 1965, 820 had been built by Boeing-Renton.

RC-135B 61-4845, one of the last 30 C-135As, powered by Pratt & Whitney TF33-P-5 turbofans, and one of ten used as photographic and electronic reconnaissance aircraft.

KC-135A 60-356 of MATS, one of four converted to RC-135D in 1962–63.

C-135B 61-331 of MATS, one of thirty built. Five C-135Bs were converted to VC-135Bs and ten were converted to WC-135Bs.

Interior view of an EC-135 Airborne Command Post. A SAC general officer and a highly skilled team of controllers and operations specialists are always on board.

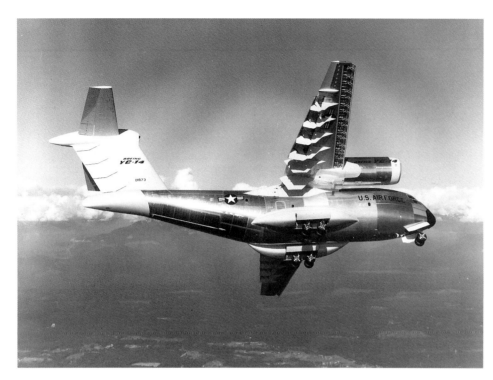

In 1972 the USAF invited manufacturers to propose potential replacements for the Lockheed C-130 Hercules. Boeing responded with the YC-14 STOL (Short Take Off and Landing) transport, powered by two 55,000lb thrust GE turbofans mounted on the wing. Two YC-14s were built (72-1873 and 1874) but no production orders were placed.

E-4A 73-1676, the first of three Advanced Airborne Command Posts, which first flew on 19 June 1973 and which was delivered to the USAF on 16 July. The E-4As were later converted to E-4B configuration.

The first E-4B built as such, with the added Super High Frequency radio housing on the fuselage. First flown 23 April 1975 and delivered to the USAF less than fully equipped on 4 August 1976, the aircraft was redelivered on 21 December 1979.

EC-137D 71-1407, one of two civil 707-320Bs in 1963 (71-1408 being the other) that were modified to serve as prototypes for a new military Airborne Warning and Control System (AWACS) with the addition of a Westinghouse AN/APY-1 radar system and large external radome. The two 707-137Ds were delivered in 1972 and redelivered as E-3As in USAF light grey/white colouring in 1977–78. Beginning in March 1977, thirty-two additional E-3A Sentries were purchased by the USAF for AWACS operations. Eighteen were later purchased by NATO, five by Saudi Arabia and four by France.

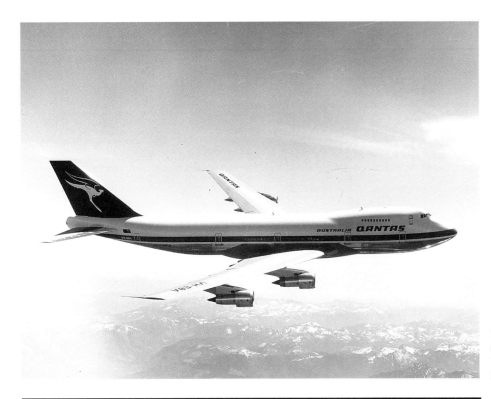

747-238BL VH-EBA of Qantas Australian Airlines, which operated a fleet of two combis and twenty-two 747-200s, the first seventeen 747Bs powered by Pratt & Whitney engines, the rest being fitted with Rolls-Royce RB.211 power plants.

747s nearing completion at Seattle in 1989. They will be moved across the highway bridge nearby at night (so as not to distract drivers), for painting in their respective airline liveries.

On 18 February 1977 747-123 N905NA (ex-N9668), the NASA Shuttle Carrier (pictured in June 1983 carrying *Enterprise* from the Paris Air Show to Stansted) made its first flight carrying the unmanned shuttle.

The first Model 757-200 (N757A) designated 757-225, fitted with Rolls-Royce RB.211 engines, flew for the first time on 19 February 1982. After modification, this aircraft first flew as the F-22 Avionics testbed on 11 March 1999. It has the nose of an F-22 mounted on its forward fuselage and a sensor wing is mounted above the cockpit. F-22 electronic warfare (EW) and communication, navigation and identification (CNI) sensors are mounted on the sensor wing. A simulated F-22 cockpit is installed in the cabin.

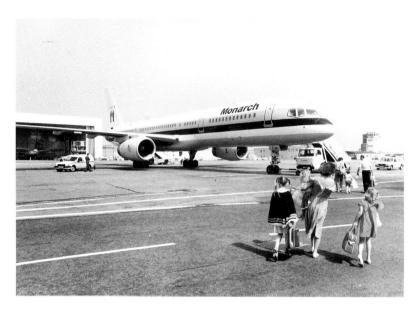

Clockwise from above: First deliveries of the 757 began in December 1982. Within six years, 368 757-200s were on order. Pictured here is Model 757-2T7 G-MONE of Monarch Airlines at Luton Airport in 1984. G-MONE (N936FD) was delivered to Federal Express (FedEx) Cargo on 28 November 2008.

The Boeing 767 prototype, designated 767-200 (N767BA), which was rolled out at Everett on 4 August 1981, flew for the first time on 26 September that year. Within seven years 316 767-200s and -300s were on order. In 2003, this aircraft was withdrawn from service and put into storage at Southern California Logistics at Victorville.

The 747 marked its twentieth anniversary on 30 September 1988 when the first built, followed by the newest model, the -400, (the 735th 747 built), flew in close formation over Seattle.

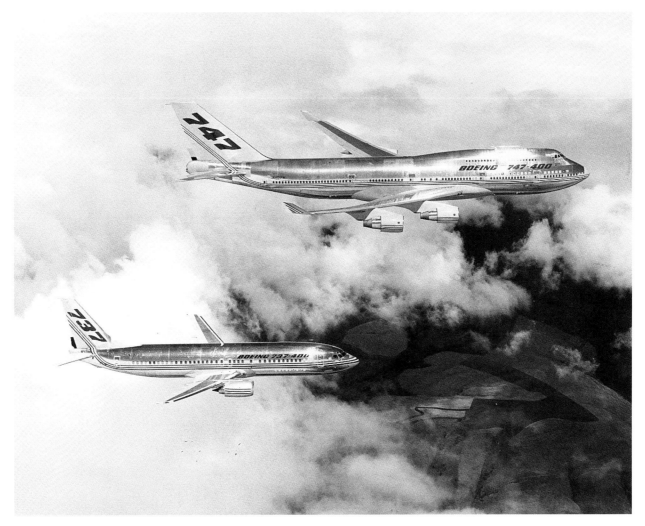

The 400-passenger 747-400 and 146-passenger 737-400, then the newest additions to the Boeing family of jet airliners, also flew in formation over the north-western United States in September 1988.

The E-3 Sentry, commonly known as AWACS, is an airborne early warning and control (AEW&C) aircraft developed by Boeing as the prime contractor. Derived from the Boeing 707, it provides all-weather surveillance, command, control and communications, and is used by the USAF, NATO, Royal Air Force, French Air Force and Royal Saudi Air Force (pictured). The E-3 is distinguished by the distinctive rotating radar dome above the fuselage. Production ended in 1992 after sixty-eight aircraft had been built. (Author)

Seven Boeing E-3A AWACS aircraft were purchased by Britain in 1991 and all were refurbished by Marshall of Cambridge (pictured). The first flight of the first E-3D Sentry for the RAF (ZH101) took place at Seattle on 5 January 1990.

RAF E-3D Sentry ZH106 in flight with a Tornado F3. No. 8 Squadron RAF operates six E-3D Sentry aircraft in the airborne surveillance and command-and-control role at RAF Waddington as the UK's contribution to the NATO Airborne Early Warning and Control Force. The E-3D also forms one arm of the UK Intelligence, Surveillance, Target Acquisition and Reconnaissance (ISTAR) triad of Sentinel R1, E-3D and Shadow R1 aircraft. While primarily procured as an airborne early warning aircraft, the E-3D has been extensively employed in the Airborne Warning and Control System (AWACS) role. The E-3D Sentry, known to the RAF as the AEW1, is based on the commercial Boeing 707-320B, which has been extensively modified and updated to accommodate modern mission systems. The E-3D is the only aircraft in the RAF's inventory capable of air-to-air refuelling by both the American 'flying-boom' system and the RAF's 'probe-and-drogue' method.

The Boeing Vertol CH-46 Sea Knight (three being prepared to lift off from the USS *Wasp*, pictured) is a medium-lift tandem rotor transport helicopter powered by twin turboshaft aircraft engines. It was used by the USMC to provide all-weather, day-or-night assault transport of combat troops, supplies and equipment until it was replaced by the MV-22 Osprey. Additional tasks included combat support, search and rescue (SAR), support for forward refuelling and rearming points, CASEVAC and tactical recovery of aircraft and personnel (TRAP). The Sea Knight was also the US Navy's standard medium-lift utility helicopter until it was phased out in favour of the MH-60S Knighthawk in the early 2000s. Canada also operated the Sea Knight, designated CH-113, and operated them in the SAR role until 2004. Other export customers included Japan, Sweden and Saudi Arabia. The commercial version was the BV 107-II, commonly referred to simply as the 'Vertol'.

The CH-47 Chinook helicopter was designed and initially produced by Boeing Vertol in the early 1960s; it is now produced by Boeing Rotorcraft Systems. To date more than 1,200 have been built and it has been sold to sixteen nations, with the US Army and the Royal Air Force (one of whom's Chinook is pictured in all-white UN livery during a British Army exercise in the Stamford battle area) being its largest users. (Author)

RAF Chinook HC2s have seen extensive service including fighting in the Falklands War, peacekeeping commitments in the Balkans and action in the Iraq and Afghanistan wars. The US Army's next generation Chinook, the CH-47D, entered service in 1982. (Author)

The Aero Spacelines Super Guppy is a large, wide-bodied cargo aircraft that is used for hauling outsize cargo components. It was the successor to the Pregnant Guppy, the first of the Guppy aircraft produced by Aero Spacelines. Five 'SGs were built in two variants, the first, directly from the fuselage of a C-97J Turbo Stratocruiser, the military version of the 1950s Boeing 377 'Stratocruiser' passenger plane.

The Shuttle Carrier Aircraft (SCA) were two extensively modified 747 airliners that NASA used to transport Space Shuttle orbiters. One is a 747-100 model, while the other is a short range 747-100SR. The SCAs were used to ferry Space Shuttles from landing sites back to the Shuttle Landing Facility at the Kennedy Space Centre and to and from other locations too distant for the orbiters to be delivered by ground transport. The orbiters were placed on top of the SCAs by Mate-Demate Devices, large gantry-like structures that hoisted the orbiters off the ground for post-flight servicing then mated them with the SCAs for ferry flights. (Author)

For the first time ever, NASA's Shuttle Carrier Aircraft 905 (foreground) and 911 (rear) were photographed as they flew in formation over the Rio Tinto Borax mine west of Boron, California, in the Edwards Air Force Base test range. NASA 905 was on a functional check flight after undergoing maintenance, while NASA 911 was aloft on a flight crew proficiency flight. (Carla Thomas)

The E-6 Mercury is an airborne command post and communications relay based on the 707-320. The original E-6A manufactured by Boeing's defence division entered service with the United States Navy in July 1989, replacing the EC-130Q.

The McDonnell Douglas (now Boeing) T-45 Goshawk is a highly modified version of the British Aerospace (now BAE Systems), Hawk land-based training jet aircraft developed as a jet flight trainer for the United States Navy and United States Marine Corps. The Goshawk first flew in 1988 and became operational in 1991.

The AH-64 Apache is a four-blade, twin-turboshaft attack helicopter with a tail-wheel-type landing gear arrangement and a tandem cockpit for a two-man crew. Originally begun as the Model 77 developed by Hughes Helicopters for the US Army's Advanced Attack Helicopter programme to replace the AH-1 Cobra, the prototype YAH-64 was first flown on 30 September 1975. In 1983 the first production helicopter was rolled out at Hughes Helicopter's facility at Mesa, Arizona. Hughes Helicopters was purchased by McDonnell Douglas for $470 million in 1984 and the helicopter unit later became part of the Boeing Company with the merger of Boeing and McDonnell Douglas in August 1997. The UK operates a modified version of the Apache Longbow initially called the Westland WAH-64 Apache and is designated Apache AH1 by the British Army. Westland built sixty-seven WAH-64 Apaches under licence from Boeing.

5

TOWARDS THE NEW MILLENNIUM

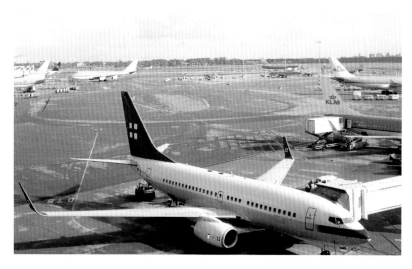

Left: The 737 short- to medium-range twinjet narrow-body airliner was originally developed as a shorter, lower-cost twin-engined airliner derived from the 707 and 727. The 737 (Swiss-based PrivatAir 737-7AK HB-JJA pictured at Schiphol) has developed into a family of ten passenger models with a capacity of 85 to 215 passengers. The 737 is Boeing's only narrow-body airliner in production, with the -700, -800, and -900ER variants currently being built. A re-engined and redesigned version, the 737 MAX, is set to debut in 2017. (Author)

Aerolineas Argentinas 737-700 LV-CAP at San Carlos de Bariloche Airport in January 2014. (Author)

British Airways (Comair) 737-4H6 ZS-OAG at Livingstone, Zambia, n 17 June 2013. (Author)

Kulula 737-8LD(WL) ZS-ZWC at Johannesburg in June 2013. (Author)

Air Austral 737-89M(WL) F-ONGA at Johannesburg in June 2013. (Author)

GOL Transportes Aereos 737-800 PR-GUD at Buenos Aires Aeroparque J. Newbery Airport in January 2014. (Author)

Air Alaska 737-800 2HI N546AS.

SAS 737-883 LN-RPM leaving Heathrow in October
2014. (Author)

Korongo 737-3M8(WL) OO-LTM at Johannesburg in
June 2013. (Author)

The 777 (British Airways 777-236 G-ZZZC pictured leaving Heathrow in October 2014) is a family of long-range wide-body twin-engine jet airliners and is the world's largest twinjet with a typical seating capacity for 314 to 451 passengers and a range of 5,235 to 8,555 nautical miles. The 777 first entered commercial service with United Airlines on 7 June 1995. As of October 2015, sixty customers had placed orders for 1,881 aircraft of all variants. (Author)

The most common and successful variant is the 777-300ER (Air France 777-300ER1, pictured) with 601 delivered and 786 orders. Emirates operates the largest 777 fleet, with 144 passenger and freighter aircraft as of July 2015.

The 777 is produced in two fuselage lengths as of 2014. The original 777-200 variant entered commercial service in 1995, followed by the extended range 777-200ER in 1997. This United 777-200ER N206UA was pictured leaving Heathrow. (Author)

The stretched 777-300 (China Airlines 777-300 pictured), which is 33.25ft longer, followed in 1998.

The longer range 777-300ER (pictured is Air Canada 777-300ER C-FITU) and 777-200LR variants entered service in 2004 and 2006 respectively, while the 777F, a freighter version, debuted in February 2009.

The X-36 was built to 28 per cent scale of a possible fighter aircraft and controlled by a pilot in a ground station virtual cockpit with a view provided by a video camera mounted in the nose of the aircraft. For control, a canard forward of the wing was used as well as split ailerons and an advanced thrust vectoring nozzle for directional control. The X-36 was unstable in both pitch and yaw axes, so an advanced digital fly-by-wire control system was used to provide stability. First flown on 17 May 1997, it made thirty-one successful research flights. McDonnell Douglas merged with Boeing in August 1997 while the test programme was in progress. Despite its potential suitability and highly successful testing, there have been no reports regarding further development of the X-36 or any derived design as of 2015.

Martinair 767-300ER PH-MCM *Prins Floris* at Havana, Cuba in October 2010. (Author)

Delta 767-400ER N833MH leaving Heathrow in October 2014. (Author)

KLM MD-11 PH-KCD *Florence Nightingale* leaving Schiphol. This aircraft was built in August 1994. Launched by McDonnell Douglas in 1986, after the company merged with Boeing in 1997 the new company decided that MD-11 production would continue but only through the freighter variant. However, in 1998 Boeing announced it would end MD-11 production after filling current orders. (Author)

Swiss Air MD-11 in flight. The last passenger MD-11 built was delivered to Sabena in April 1998. Assembly of the last two MD-11s was completed in August and October 2000 and they were delivered to Lufthansa Cargo in January/February 2001. Studies on the feasibility of removing the tail engine to make a twin-engine jet were not successful. Only 200 MD-11s were built.

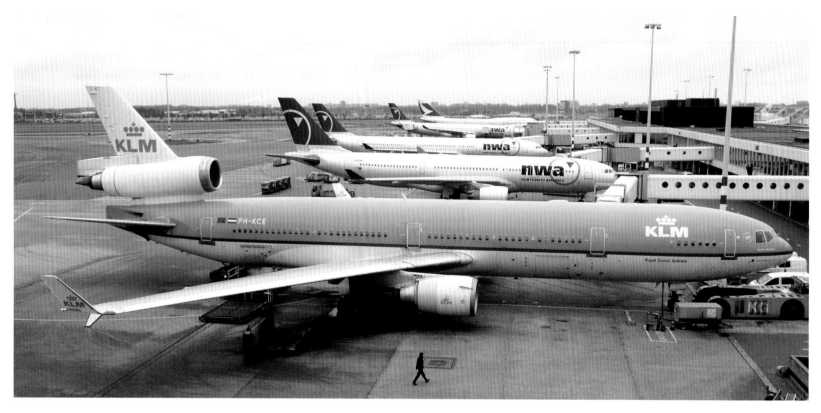

KLM MD-11 PH-KCE *Audrey Hepburn* at Schiphol, Amsterdam. This aircraft was built in October 1994. (Author)

The Bird of Prey experimental aircraft had a service life of just three years before being retired in April 1999.

F/A-18 Super Hornets of US Navy Strike Fighter Squadron 31 flying a patrol over Afghanistan on 15 December 2008. The F/A-18E single-seat and F/A-18F tandem-seat variants are larger and more advanced derivatives of the F/A-18C and D Hornet. The Super Hornet has an internal 20mm M61 rotary cannon and can carry air-to-air missiles and air-to-surface weapons. Additional fuel can be carried in up to five external fuel tanks and the aircraft can be configured as an airborne tanker by adding an external air refuelling system. The Super Hornet first flew in 1995. Full-rate production began in September 1997 after the merger of McDonnell Douglas and Boeing and the aircraft entered service with the US Navy in 1999, replacing the Grumman F-14 Tomcat, which was retired in 2006.

F/A-18E Super Hornet taking off from a carrier.

F/A-18 Super Hornet of CVW-5 (Carrier Air Wing 5) VFA-27 'Royal Maces' from the USS *Kitty Hawk* passing Mount Fuji, Japan.

The EA-18G Growler (RAAF EA-18G, pictured) is a carrier-based electronic warfare aircraft, a specialised version of the two-seat F/A-18F Super Hornet. The EA-18G replaced the Northrop Grumman EA-6B Prowlers in service with the US Navy. The RAAF, which has operated the F/A-18A as its main fighter since 1984, ordered the F/A-18F in 2007 to replace its ageing F-111 fleet. RAAF Super Hornets entered service in December 2010. As part of the order for 24 F/A-18F Super Hornets, twelve would be wired on the production line for future fit-out as EA-18Gs; making the RAAF the only military other than the US to operate the Growler's electronic jamming equipment. Australia took delivery of the first of twelve new-build Growlers on 29 July 2015, with delivery of the remaining jets expected by 2017. Uniquely, Australian Growlers will be equipped with the ASQ-228 ATFLIR targeting pod and will also have additional AIM-9X air-to-air missiles.

Bell-Boeing MV-22 Osprey in the East China Sea on 9 February 2015. The Bell Boeing V-22 Osprey is a multi-mission, tiltrotor military aircraft with both a vertical take-off and landing (VTOL) and short take-off and landing (STOL) capability. It is designed to combine the functionality of a conventional helicopter with the long-range, high-speed cruise performance of a turboprop aircraft. The V-22 originated from the US DoD Joint-service Vertical take-off/landing Experimental (JVX) aircraft programme started in 1981. The team of Bell Helicopter and Boeing Helicopters was awarded a development contract in 1983 and the V-22 first flew in 1989. USMC crew training began in 2000 and entered service in 2007, first supplementing and then replacing the CH-46 Sea Knight. The USAF introduced its version in 2009. Since entering service the Osprey has been deployed in transportation and medivac operations over Iraq, Afghanistan, Libya and Kuwait.

Alaska Airlines launched the 737-900 in 1997 and accepted delivery on 15 May 2001. The 737-900ER, which was called the 737-900X prior to launch, is the largest variant of the Boeing 737 line and was introduced to meet the range and passenger capacity of the discontinued 757-200 and to compete directly with the Airbus A321. An additional pair of exit doors and a flat rear pressure bulkhead increased the seating capacity to 180 passengers in a two-class configuration or 220 passengers in a single-class layout. Additional fuel capacity and standard winglets improved the range to that of other 737NG variants. The first 737-900ER was rolled out of the Renton, Washington, factory on 8 August 2006 for its launch customer, Lion Air (pictured). The airline had orders for 132 737-900ERs as of August 2015. As of September 2015, fifty-two -900s, 354 -900ERs and six -900 BBJ3s had been delivered with 148 unfilled orders.

The X-32B demonstrator lifts off on its maiden flight from the company's facility in Palmdale, California. Following a series of initial airworthiness tests, the X-32B, with Boeing JSF lead short take-off and vertical landing (STOVL) test pilot Dennis O'Donoghue at the controls, landed at Edwards Air Force Base, California. The X-32B completed a number of flights at Edwards before moving to Naval Air Station Patuxent River, Maryland, for the majority of STOVL testing. The overall flight-test programme included approximately fifty-five flights totalling about forty hours.

The unpiloted X-40A Space Maneuver Vehicle was a test platform for the X-37 Future-X Reusable Launch Vehicle. After the first drop test in August 1998 the vehicle was transferred to NASA, which modified it. Between 4 April and 19 May 2001 the vehicle successfully conducted seven free flights. In 2001 it successfully demonstrated the glide capabilities of the X-37's fat-bodied, short-winged design and validated the proposed guidance system.

The X-45A unmanned combat air vehicle (UCAV) Prototype made its maiden flight on 22 May 2002 and the second vehicle followed in November of that year. On 18 April 2004 the X-45A's first bombing run test at Edwards Air Force Base was successful; it hit a ground target with a 250lb inert precision-guided munition. On 1 August 2004, for the first time, two X-45As were controlled in flight simultaneously by one ground controller. After the completion of the flight test programme, the X-45As were sent to the National Air and Space Museum and the other to the National Museum of the USAF at Wright-Patterson AFB, where it was inducted on 13 November 2006.

Clockwise from right: Four extensively modified 747 airliners serve as the fleet of Dreamlifter 747-400CL heavy-lift transports and are used exclusively for transporting 787 aircraft parts to Boeing's assembly plants from suppliers around the world. Formerly Large Cargo Freighter or LCF the Dreamlifter (747-400LCF pictured) is a wide-body cargo aircraft. The first two LCFs entered service in 2007 to support the final assembly of the first 787 Dreamliners.

Dreamlifter N7808A. (Gerry Manning)

Loading a fuselage aboard a Dreamlifter; cargo is placed in the aircraft by the world's longest cargo loader.

The Boeing ScanEagle is a small, long-endurance unmanned aerial vehicle built by Insitu, a subsidiary of Boeing. The ScanEagle was designed by Insitu based on the Insitu SeaScan, a commercial unmanned aerial vehicle (UAV) that was intended for fish spotting.

The 757 mid-size, narrow-body twin-engine jet airliner (Republica Argentina 757-23A government jet T-01, pictured at Buenos Aires Aeroparque J. Newbery Airport on 13 January 2014) was Boeing Commercial Airplanes' largest single-aisle passenger aircraft and was produced from 1981 to 2004. The stretched 757-300, the longest narrow-body twinjet ever produced, began service in 1999. (Author)

Northwest Airlines first placed the 747-400 in commercial service on 9 February 1989. The 747-400 (Lufthansa 747-430 D-ABVU pictured) was produced in passenger (-400), freighter (-400F), combi (-400M), domestic (-400D), extended range passenger (-400ER) and extended range freighter (-400ERF) versions. The 747-400 has now been superseded by the more economical and advanced 747-8. (Gerry Manning)

Singapore Airlines Cargo 747-400F Mega Ark. SIA Cargo operates 11 747-400F freighters and manages the bellyhold freight of all Singapore Airlines and Scoot aircraft. (Gerry Manning)

Eva Air 747-400 B-6405. (Gerry Manning)

British Airways 747-436 G-CIVR leaving Heathrow in October 2014. (Author)

Thai Airways International 747-4D7 HS-TGO *Amazing Thailand*. (Gerry Manning)

Virgin Atlantic 747-200 G-VJFK *Boston Belle* at London-Gatwick on 1 March 1999. G-VGIN *Scarlet Lady*, G-VIRG *Maiden Voyager*, *Boston Belle* and G-VLAX *California Girl* were withdrawn in 2001. (Author)

British Airways 747-436 G-CIVM *Nami Tsuru* at Denver, Colorado, on 2 March 1999. This aircraft first flew on 27 May 1997. (Author)

An F-15E taking off during Red Flag Alaska.

F-15 Eagle and a Lockheed-Martin F-22 Raptor in formation.

An F-15E Strike Eagle air superiority fighter of the 391st Fighter Squadron on a mission over Afghanistan in November 2008.

The 737 AEW&C has also been selected by the Turkish Air Force under Project Peace Eagle (Royal Turkish Air Force 737-7ES AEW&C Wedgetail pictured) and the Republic of Korea Air Force (Project Peace Eye) and has been proposed to Italy and the United Arab Emirates.

The 737 AEW&C is a twin-engine airborne early warning and control aircraft, lighter than the 707-based E-3 Sentry, and mounts a fixed, active electronically scanned array radar antenna instead of a rotating one. It was designed for the RAAF under Project Wedgetail (737-7ES N378BC AEW&C pictured) and designated E-7A Wedgetail. The RAAF accepted its sixth and final AEW&C aircraft on 5 June 2012.

United Airlines 787-8 Dreamliner
N26909 leaving Heathrow. (Author)

Dreamliner 787-9 ZB-001 (N789EX)
getting airborne from Paine Field on
17 September 2013, the first new
Boeing wide-body to fly since the
787-8 in December 2009. The -9 is
approximately 20ft longer than the -8
variant.

LOT Polish Airlines 787-8 SP-LRA first Dreamliner, on a test flight over Washington State in November 2012.

Officially announced in 2005, the 747-8 (N6067E is pictured on an early test flight) is the third generation of the 747, with lengthened fuselage, redesigned wings, and improved efficiency.

The 747-8 is the largest commercial aircraft built in the United States and the longest passenger aircraft in the world. It is offered in two main variants: the 747-8 Intercontinental (747-8I) for passengers and the 747-8 Freighter (747-8F) for cargo. The first 747-8F performed the model's maiden flight on 8 February 2010 with the 747-8 Intercontinental following on 20 March 2011. Delivery of the first freighter aircraft occurred in October 2011 and the passenger model began deliveries in 2012.

Lufthansa 747-8 D-ABYA landing at Frankfurt in 2012. Lufthansa became the first airline in the world to take delivery of a 747-8. D-ABYA performed a touch and go at Hamburg Airport, where Lufthansa Technik is based, before flying on to its future home base in Frankfurt, where it landed. On 1 June the world's first passenger flight with a 747-8 aircraft departed from Frankfurt as flight LH 418 bound for Washington Dulles International Airport in Washington DC.

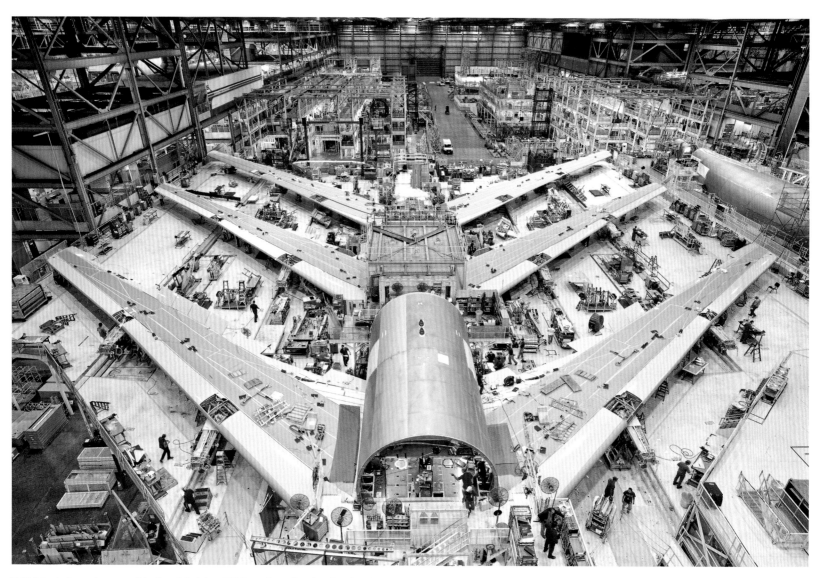

747-8 test planes in assembly. As of October 2015 confirmed orders for the 747-8 totalled 119, comprising sixty-one of the freighter version and fifty-one of the passenger version.

In a joint venture of NASA and DLR a former Pan Am 747SP was modified to Stratospheric Observatory for Infrared Astronomy (SOFIA) to carry a large infrared-sensitive telescope. High altitudes are needed for infrared astronomy, so as to rise above infrared-absorbing water vapour in the atmosphere. The aircraft had previously flown with Pan Am, then United Airlines. On 30 April 1997 the Universities Space Research Association (USRA) purchased the aircraft for use as an airborne observatory.

Passenger 757-200s have been modified to special freighter (SF) specification for cargo use, while military derivatives include the C-32 transport, VIP carriers (C-32A Air Force Two is pictured landing at the Kentucky ANG base) and other multi-purpose aircraft. Private and government operators have also customised the 757 for research and transport roles. All 757s are powered by Rolls-Royce RB211 or Pratt & Whitney PW2000 series turbofans.

The A160 Hummingbird YMQ-18A is an unmanned aerial vehicle (UAV) helicopter. Its design incorporates many new technologies never before used in helicopters, allowing for greater endurance and altitude than any helicopter currently in operation. The development of Hummingbird was begun for the Defense Advanced Research Projects Agency (DARPA) by Frontier Aircraft in 1998. From 2003 both the US Army and the US Navy also shared in funding the project. In May 2004, the company was acquired by Boeing and became integrated into Boeing Phantom Works, and then into the Advanced Systems group of Boeing Integrated Defence Systems.

The Boeing X-48 is an experimental unmanned aerial vehicle (UAV) for investigation into the characteristics of blended wing body (BWB) aircraft, a type of flying wing. Boeing designed the X-48 and two examples were built by Cranfield Aerospace in the UK. Boeing began flight-testing the X-48B version for NASA in 2007. The X-48B was later modified into the X-48C version. It was flight tested from August 2012 to April 2013.

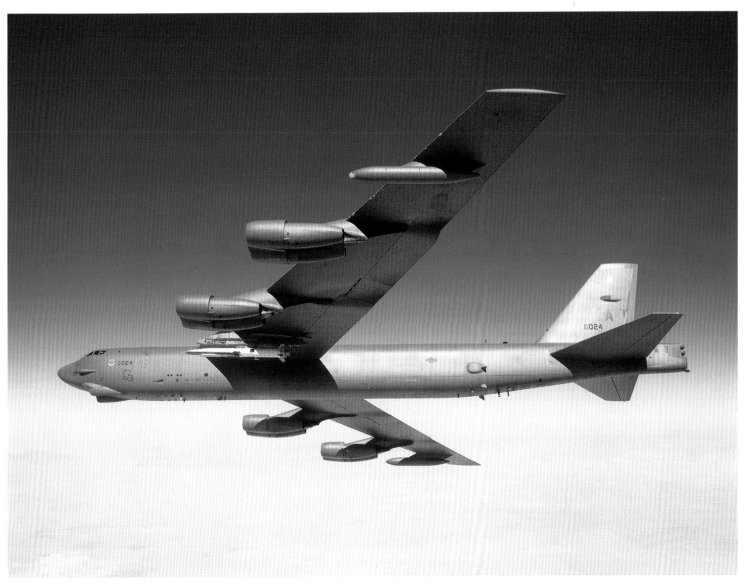

The X-51 WaveRider, which uses its shock waves to add compression lift (seen here mounted under the wing of a B-52G) is an unmanned scramjet demonstration aircraft for hypersonic (Mach 6, approximately 4,000mph at altitude) flight testing. It completed its first powered hypersonic flight on 26 May 2010. The X-51 completed a flight of more than six minutes and reached speeds of more than Mach 5 for 210 seconds on 1 May 2013 for the longest duration hypersonic flight. X-51 technology will be used in the High Speed Strike Weapon (HSSW), a Mach 5+ missile planned to enter service in the mid-2020s.

The P-8 Poseidon, which first flew on 25 April 2009, was developed for the US Navy by Boeing Defense, Space & Security, modified from the 737-800ERX. The P-8 conducts anti-submarine warfare (ASW), anti-surface warfare (ASUW) and shipping interdiction. It also conducts an electronic signals intelligence (ELINT) role carrying torpedoes, depth charges, standoff land attack missile expanded response (SLAM-ER) missiles, Harpoon anti-ship missiles and other weapons and is able to drop and monitor sonobuoys. It is designed to operate in conjunction with the Northrop Grumman MQ-4C Triton Broad Area Maritime Surveillance unmanned aerial vehicle. The project was planned to be for at least 108 airframes for the US Navy and has been ordered by the Indian Navy as the P-8I Neptune and the RAAF. The RAF is to acquire nine P-8s.

Clockwise from right: The Air Force had once thought it might have as many as seven airborne but in funding for the programme was cut in 2010 and it was cancelled in December 2011. YAL-1A 00-0001 made its final flight on 14 February 2012 to Davis-Monthan Air Force Base in Tucson, Arizona, to be prepared and kept in storage.

The E-4B 'Nightwatch' Advanced Airborne Command Post was specially modified from the 747-200B and is a strategic command and control military aircraft operated by the USAF (seen here at El Dorado airport, Bogota, Columbia). It is denoted a National Airborne Operations Center when in action. The E-4 fleet was originally deployed in 1974 when it was termed National Emergency Airborne Command Post (NEACP, or 'kneecap').

The E-4B 'Nightwatch' serves as a survivable mobile command post for the National Command Authority, namely the President of the United States, the Secretary of Defense and successors, and is designed to survive an electromagnetic pulse (EMP) with systems intact and has state-of-the-art direct fire countermeasures. Although many older aircraft have been upgraded with glass cockpits, the E-4B still uses traditional analog flight instruments, as they are less susceptible to damage from an EMP blast. The E-4B is capable of operating with a crew up to 112 people including flight and mission personnel; the largest crew of any aircraft in USAF history. The four E-4Bs are operated by the 1st Airborne Command and Control Squadron of the 55th Wing located at Offutt AFB near Omaha, Nebraska.

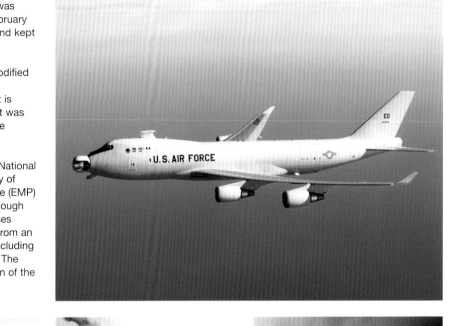

Above: The Evergreen 747 Supertanker (N740EV) is a 747-200 modified as an aerial application platform for fire fighting using 20,000 US gallons (76,000 litres) of fire-fighting chemicals. To date two aircraft have been converted. The tanker made its first American operation on 31 August 2009 and has also been deployed to Israel to fight an uncontrolled fire on Mount Carmel. The Supertanker's tank system can be configured for segmented drops, allowing the contents of the tank to be released at multiple intervals while in flight.

Left: The 737 MAX is being developed as the successor to the 737 Next Generation series and is the fourth generation of the 737 family, with larger and more efficient CFM International LEAP-1B engines and modifications to the airframe. As of December 2015, Boeing had 3,072 firm orders for the aircraft. The 737 MAX first flew on 29 January 2016 and is scheduled for first delivery in 2017.

Colombian Air Force KC-767-2J6ER is a military aerial refuelling and strategic transport aircraft developed from the 767-200ER. The tanker received the designation KC-767A after being selected by the US Air Force initially to replace older KC-135Es. In December 2003 the contract was frozen and later cancelled due to corruption allegations. The tanker was developed for the Italian and Japanese air forces, who ordered four tankers each. Financing of the development of the aircraft has largely been borne by Boeing in the hope of receiving major orders from the US Air Force. The revised KC-767 proposal was selected in February 2011 for the KC-X programme under the designation KC-46.

KC-46A Pegasus N461FT in flight. The first eighteen combat-ready aircraft are to be delivered to the US Air Force by August 2017 under the terms of the development contract.

If you enjoyed this book, you may also be interested in …

978 0 7509 3980 5

978 0 7509 4485 4